PAINTING
HOUSES & GARDENS
in watercolour

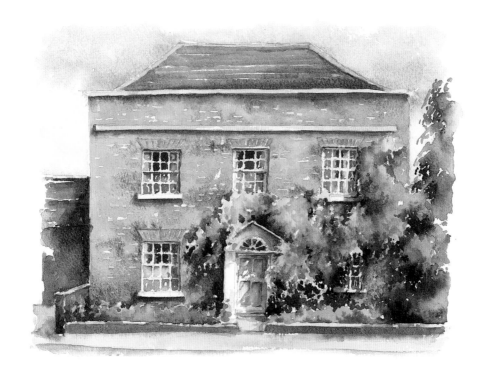

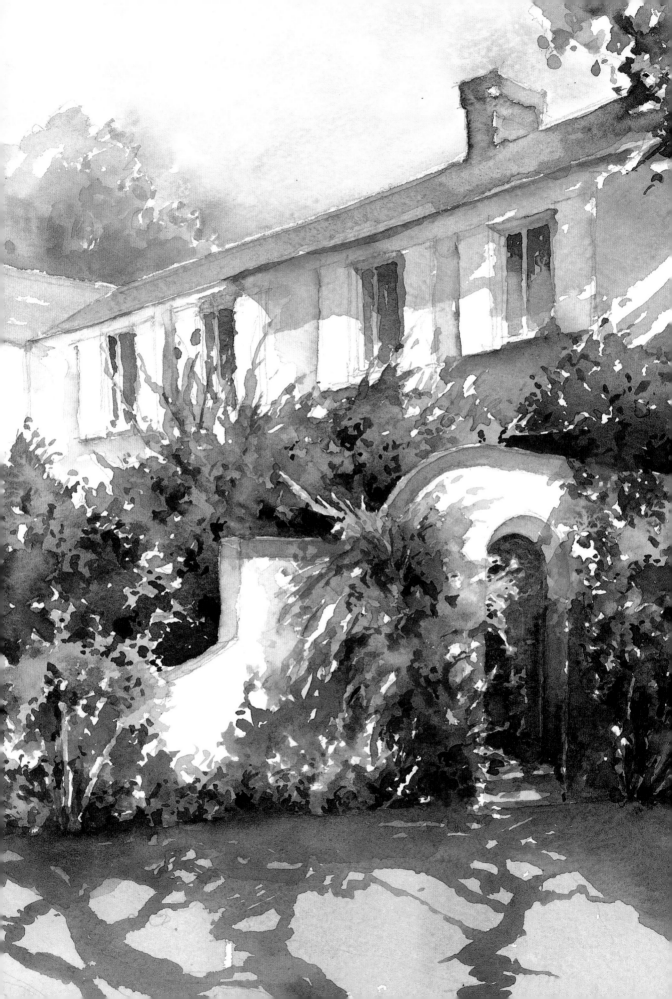

PAINTING
HOUSES & GARDENS
in watercolour

Richard Taylor

First published in 2003 by
Collins, an imprint of
HarperCollins*Publishers*
77-85 Fulham Palace Road
Hammersmith, London W6 8JB

The Collins website address is:
www.collins.co.uk

Collins is a registered trademark of HarperCollins
Publishers Limited.

07 06 05 04 03
6 5 4 3 2 1

**A catalogue record for this book is available
from the British Library**

Editor: Geraldine Christy
Designer: Penny Dawes
Photographer: George Taylor

ISBN 0 00 711504 0

Colour reproduction by Colourscan, Singapore
Printed and bound in Great Britain by
Butler & Tanner Ltd, Frome and London

PAGE 1: *Georgian House*, 24 × 32 cm (9½ × 12½ in)
PAGE 2: *Orchard Shadows*, 30 × 28 cm (12 × 11 in)

Contents

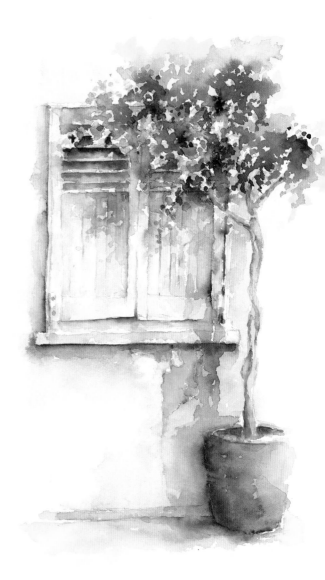

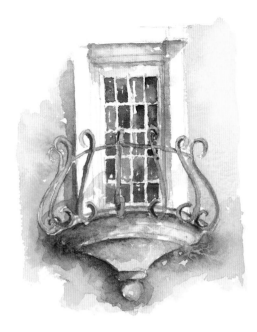

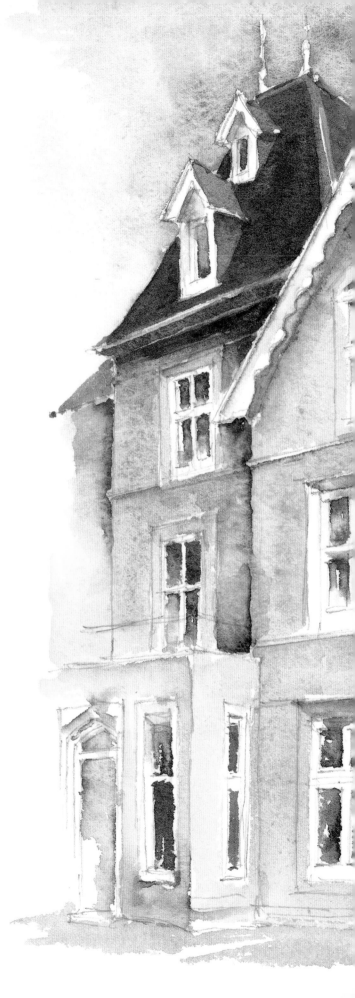

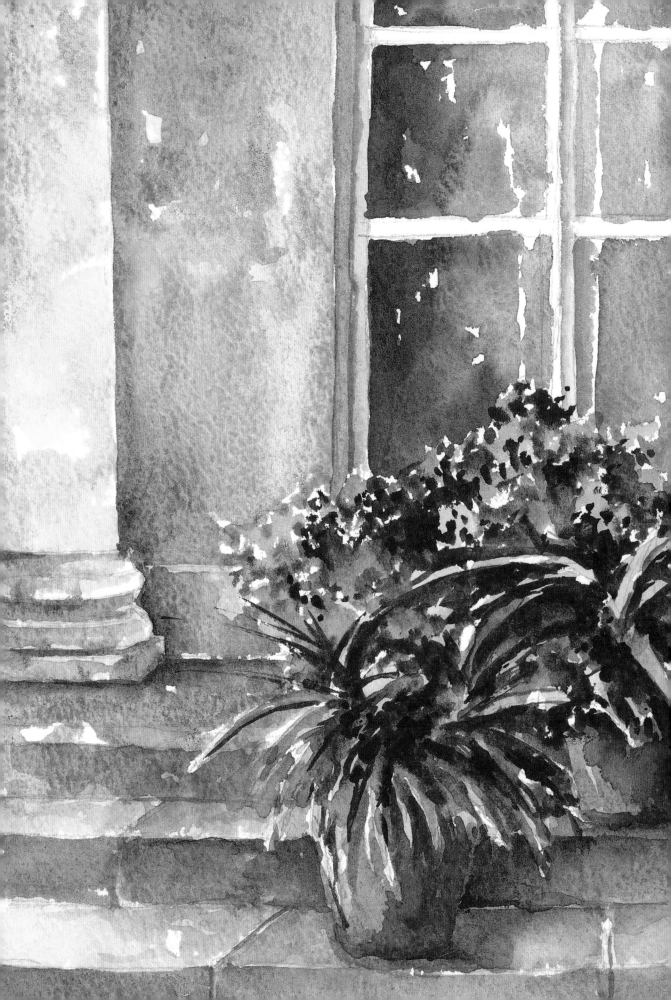

Introduction

Through history people have personalized their houses to make them into welcoming homes. As society became more affluent so the desire to make an outward statement about status resulted in the elaborate and decorative features that are part of the character of each individual home today.

Gardens, too, first used simply for growing food, have developed into attractive landscaped areas with flowers and shrubs that enhance the setting of the home. Together house and garden provide an ideal, easily accessible subject for the watercolour painter.

◀ **Stone Steps**
26 × 28 cm (10 × 11 in)

A guided tour

The aim of this book is to explore the techniques for painting houses and gardens in watercolour, and to do so I have planned it almost as a guided tour. Let us look at the front of the home first and gradually work round to the rear.

The starting point for the tour begins with textures, looking at the fabric that most houses are made from. This includes the colours that you are likely to use (and how and why they appear as they do) as well as the surfaces that you will need to re-create to paint convincing pictures of both old and new houses.

The next 'stop' is at sketchbook studies, considering the best way to approach most of our paintings, then moving on to explore how these sketches can be developed into compositions and how to establish the correct sense of perspective.

Having covered the basic skills, the book progresses to look at the different types of homes that you are likely to find, offering pointers to specific features that you may want to study, with advice on colours and textures.

The transition begins with the section on 'Features and Details', which leads you past the front doorway and on towards the garden. Once in these more private places another world of painting houses and gardens opens up, the first of these areas being the conservatory. Initially we shall tackle the inside, particularly taking into consideration the direction of the light. Then we shall move outside to consider reflections, diffused lighting, and how these home extensions look from both points of view, allowing you a complete overview of the built environment – from front to back.

▼ **Half-timbered House**
23 × 28 cm (9 × 11 in)

An on-site sketch can be done quickly, but still gives you much visual information to take home with you and to work on later in the studio.

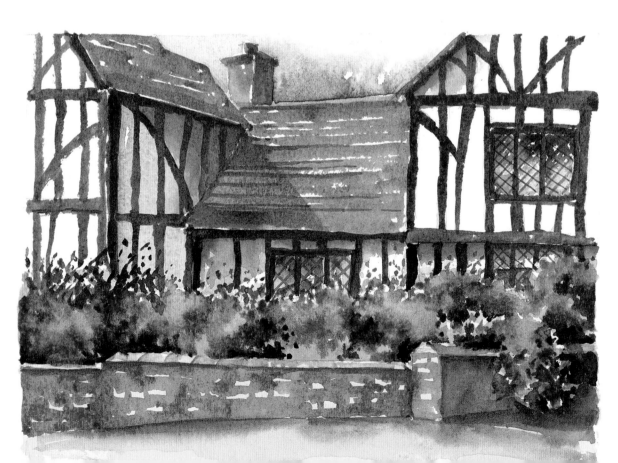

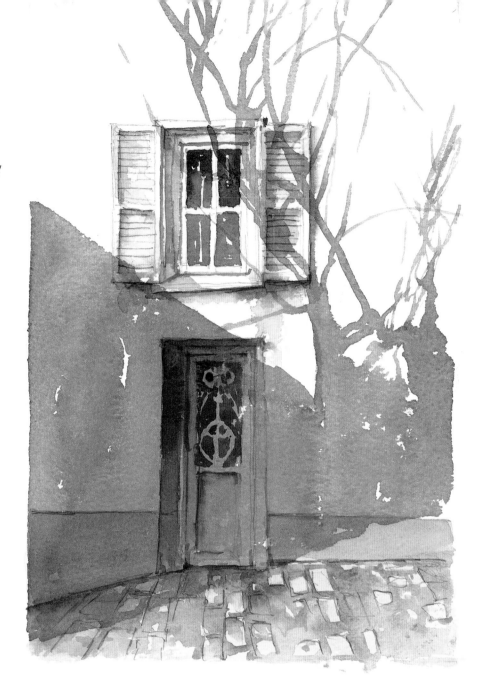

▶ **Parisian Doorway**
28 × 23 cm (11 × 9 in)

*This building has little
visual interest to
emphasize until you add
a substantial shadow –
then it comes alive.*

Around the garden

The textures found in 'accidental still-life'
groups that are likely to be discovered on the
musty potting-shed floor, or the rusting
wheelbarrow leaning against the old brick
outbuilding are considered a vital part of the
character of a house and are valuable subjects
for painting.

The final stop on the 'tour' is in the garden –
not just for flowers, but for fruit, vegetables,
dappled shadows, garden furniture and general
outdoor living – in fact, all of the elements
that contribute to making a building into
more than just a house, but rather a home,
throughout the seasons.

So, having taken the tour from the front to
the back of the house, looking inside and out,
it is now time to hand the paints and
watercolour pad over to you to explore your
own neighbourhood. You will find that your
own district holds a wealth of personalized
houses for you to paint.

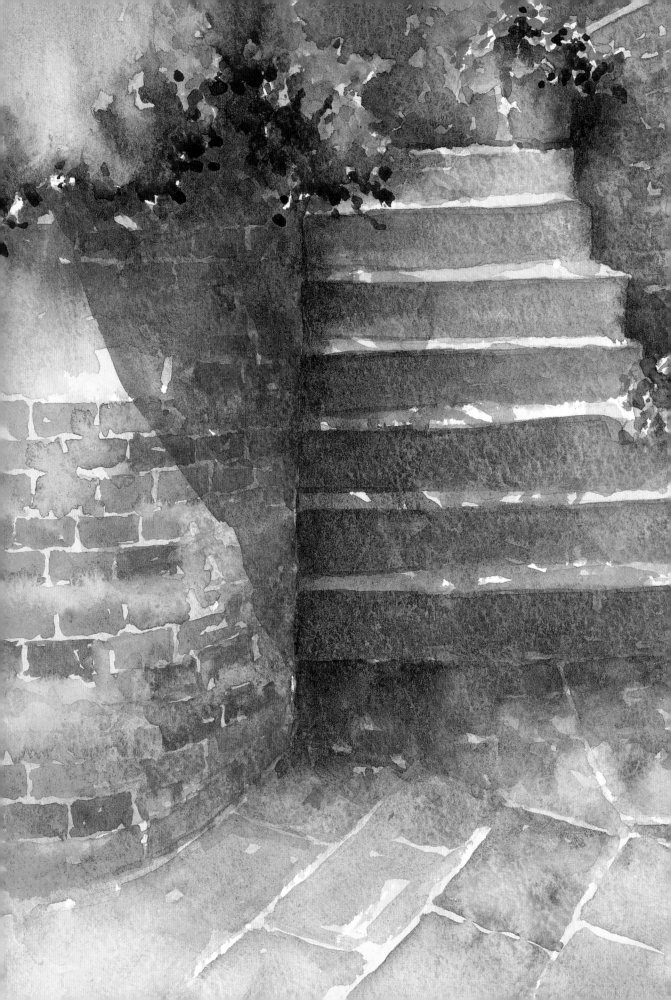

Materials

A beauty of watercolour painting is the simplicity of the materials required to get started – just a handful of paints, a surface to mix them on, a brush and some paper – nothing more than that!

Of course, the more suitable the paints, the more convincing the colours will be, and the more appropriate the paper, the better the paints will work together with it, creating the right textures.

This chapter looks at the simple, yet specific, equipment that I recommend for painting houses and gardens in watercolour.

◀ **Back Passageway**
26 × 28 cm (10 × 11 in)

Studio equipment

As do many artists I have two distinct sets of equipment – one set that stays in the studio and another set that lives in a canvas bag. The studio set is made up of tube paints and a white plastic palette, a handful of sable brushes and sheets of 535 gsm (250 lb) Bockingford watercolour paper. The reason that I use tube paints in the studio is that I can achieve some very strong colour mixes by controlling the amount that I squeeze out.

▼ *My studio equipment is simple and straightforward, and can be put away in one big box. This saves space and everything is conveniently to hand.*

A dark mixture can be created through sheer volume of paint and tube paints have the advantage over pan paints for this. They are, however, easy to lose or misplace when working 'on site'.

I personally choose sable brushes for their 'holding' power and their ability always to return to a reasonable point even after 'scrubbing' some paint. Generally I use only three brushes – a small one for picking out details, a medium one for general use, and a large one for skies or blocking in broad areas.

I choose to use a heavyweight paper for watercolour painting for the simple reason that it does not need stretching and allows a great deal of water to soak in before it shows any signs of twisting or cockling.

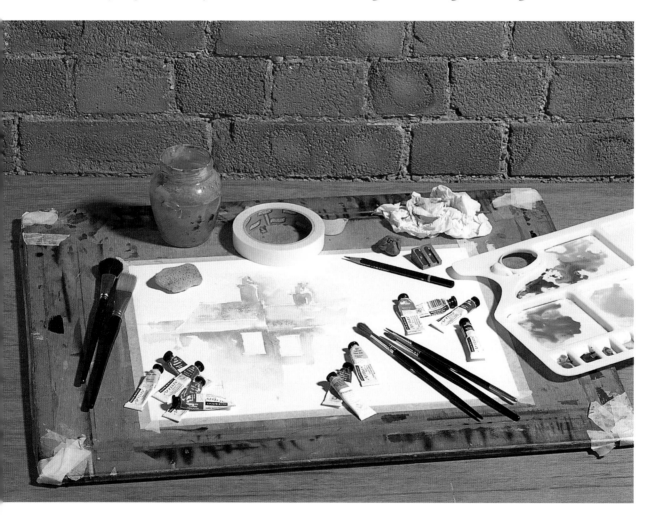

◀ Working outdoors I use a simpler range of equipment than in the studio. My materials all fit into a canvas bag that can be transported easily.

Outdoor equipment

In my outdoor sketching bag I keep a watercolour tin with a selection of twelve half-pan paints. The tin also holds a retractable brush, which saves a lot of space and prevents the problem of bent bristles that other brushes have suffered from in my bag in the past.

I carry a selection of watersoluble pencils – both colour and graphite – as I find they are ideal for making quick colour notes. I also like the way in which so many interesting textures can be created by drawing with damp pencils onto dried washes.

For paper I always carry a hard-backed ring-bound pad – usually 300 gsm (140 lb) paper. These pads are ideal for sketching and painting 'on site' as you do not need to carry a separate drawing board. Also, you can keep your work safe simply by turning over the page with a ring-bound pad. If you have to tear off a page, you will need somewhere to keep it.

I do not carry folding stools or easels with me on painting trips as I firmly believe in simplicity, both outdoors and in the studio.

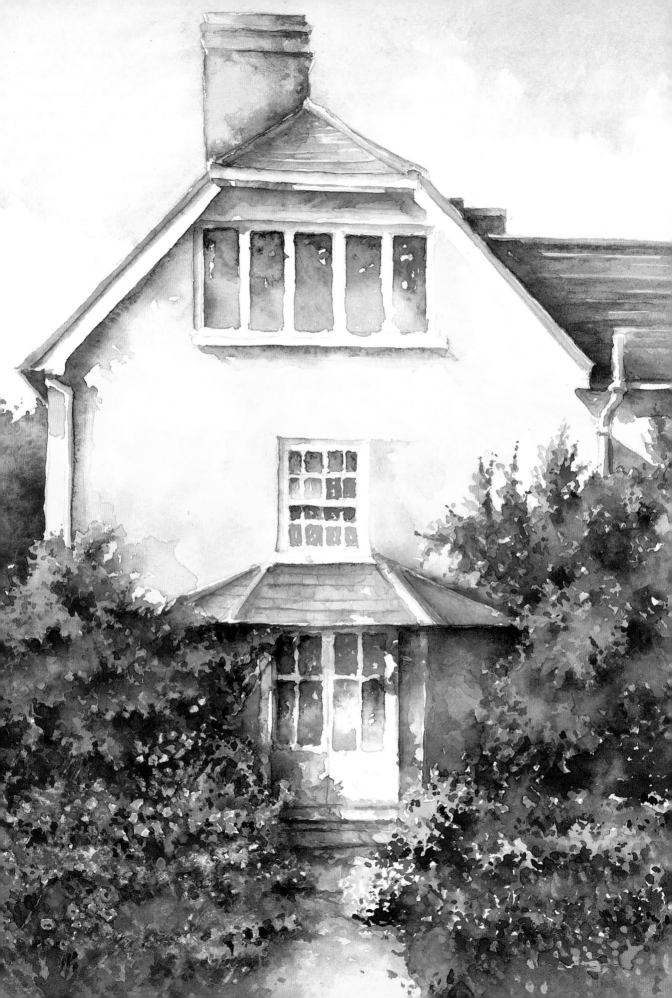

Exploring Colour

Experimenting with different colours, and watching a scene change its mood according to the paints that you choose, is one of the true joys of painting.

This chapter looks at some of the aspects of colour that you will need to consider when painting houses and gardens — how, for instance, to mix appropriate colours for brick, stone or foliage, how warm or cool colours can effectively suggest atmosphere, and how complementary colours, carefully placed, can make your picture really come alive.

◀ **Charlston Farmhouse** *(detail)*
31 × 47 cm (12 × 18½ in)

Natural earth colours

Raw Sienna Burnt Sienna Burnt Umber

Most houses or homes that you are likely to come across in your search for subjects will be made of brick or stone, or possibly covered with plaster or stucco. As these are natural building materials (the majority of their component parts come from the earth) it seems appropriate that the best colours to use to paint them are the 'earth' colours. These paints were originally made from pigments dug directly from the earth, but only the most expensive of hand-made paints contain these pigments today; the majority are now made from artificial substitutes.

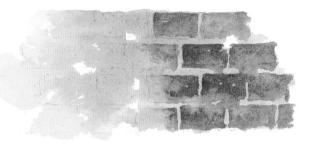

▲ *A Raw Sienna underwash, painted onto dry paper, acts as a visual anchor, setting the tone for the colours to be painted on top. Burnt Sienna is added next and the warm glow of the underwash allows the red brick colour to come alive. Finally, the Burnt Umber is added to lend a little 'weight' to the wall.*

Brick and stone colours

Bricks usually hold a strong reddish tone, with darker bricks that may have been burned in the kiln taking on a blue/brown patina. Raw Sienna is a warm, yellow paint that is ideal for underwashing brickwork. It is a strong colour that will show through the subsequent coats.

▼ *Small studies of brick walls are useful to make before attempting an entire wall. Use lots of water and let the colours run and bleed – they are from the same 'family', so will not look out of place as they bleed.*

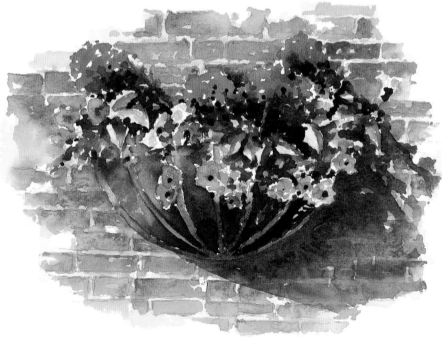

Natural earth colours

Raw
Sienna

Burnt
Sienna

Raw
Umber

Burnt
Umber

A ground of Raw Sienna will warm up any painting. Burnt Sienna is a rich reddish paint that is close to most brick types in colour. When painted over a Raw Sienna underwash this colour almost glows with the warmth of the baked Mediterranean earth. Darker bricks will benefit from the addition of a little Burnt Umber, a warm brown paint.

Warm stone is also best started with a wash of Raw Sienna. Cooler or older stone, however, may benefit from an underwash of Raw Umber. This paint often dries with a slight olive tint. Burnt Umber, predictably, reacts very well with Raw Umber to create a natural stone appearance. All of these paints can be used to good effect with a lot of water as they are all prone to granulate. This is an effect in which the granules of the pigment can be seen in the dry paint. Granulation always helps to add a sense of texture to both brick and stonework – the more water you add, the higher are the chances of granulation occurring.

Raw Umber Burnt Umber

Raw Sienna French Ultramarine

▶ **Georgian Terrace**
36 × 18 cm (14 × 7 in)

The 'yellow' Raw Sienna and Raw Umber colours are well suited to painting old stone and stucco. Darken these by adding Burnt Umber and French Ultramarine. Let them run and bleed to give a more natural appearance.

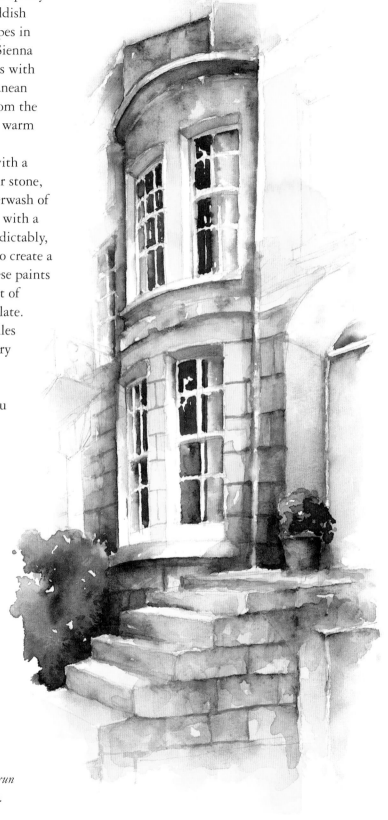

Warm and cool colours

The atmosphere of any day is best captured by choosing the correct colours to paint the sky and the shadows. The warm violet shadows of a late summer afternoon, for instance, require different coloured paints from the cool, windswept skies of a spring day. Bright skies and shadows can occur in any season, however, so the key to suggesting the difference between a late autumnal day or a chilly winter's day lies mainly in your choice of blues for sky and shadow mixes.

▶ *This chart demonstrates a variety of warm and cool colours created by mixing into a base colour of Sap Green.*

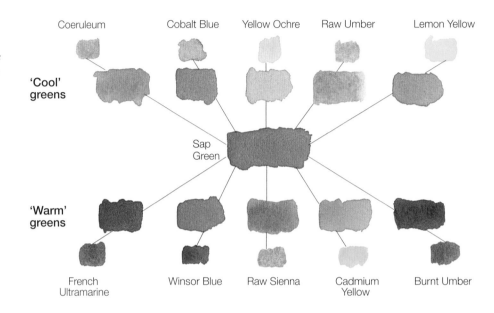

Coeruleum Cobalt Blue Yellow Ochre Raw Umber Lemon Yellow

'Cool' greens

Sap Green

'Warm' greens

French Ultramarine Winsor Blue Raw Sienna Cadmium Yellow Burnt Umber

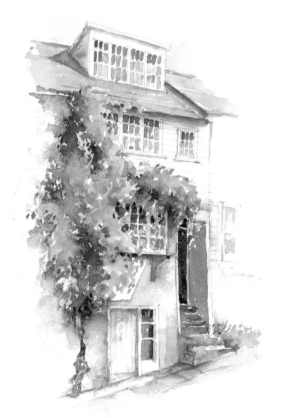

Coeruleum

Cobalt Blue

Raw Umber

◀ *The cool, sharp shadows cast onto this whitewashed building mirror the colours found in the sky. Two 'cool' blues were mixed together to form both the sky and the base colour for the shadows. Raw Umber is a cooler version of Raw Sienna and was used here as the underwash for the ground and stone colours.*

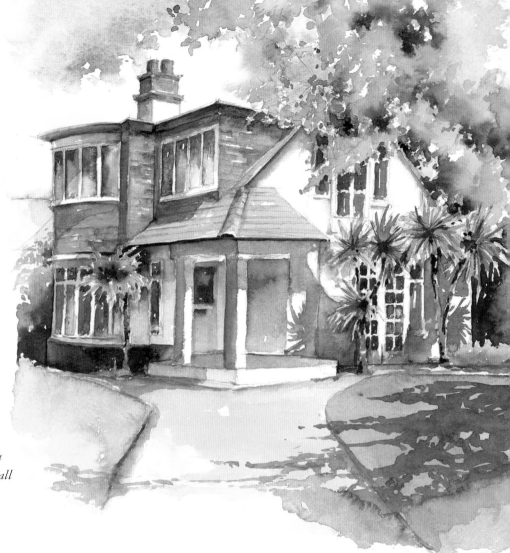

▶ Suburban Home
36 × 26 cm (14 × 10 in)

The long, sun-drenched shadows cast onto this house were enhanced with violet to recreate the warmth of the morning. French Ultramarine and Alizarin Crimson are used for this warm shadow mixture, varied according to the strength of tone required. Sap Green is the 'base' colour for varied foliage, with Cadmium Yellow and Raw Sienna added to cement the overall warm, summery feeling.

Choosing blues

Experiment a little to discover which particular blues hold specific qualities. French Ultramarine, for example, is considered to be the 'warmest' of blues and will usually form the basis of summer skies and shadows (often enhanced with a touch of Alizarin Crimson to warm it up even more). Coeruleum, on the other hand, is a cooler blue and excellent to use (along with Cobalt Blue) to capture the sharp, fresh chill of a brightly sunlit springtime scene.

Many other paint colours have temperatures attributed to them and these need to be considered in your seasonal choices of mixture for trees, foliage, glass reflections and even the fabric of a building.

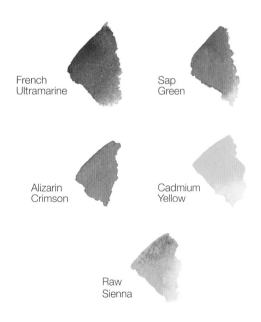

French Ultramarine

Sap Green

Alizarin Crimson

Cadmium Yellow

Raw Sienna

Complementary colours

It is through the late-nineteenth-century Impressionist, and early-twentieth-century Fauvist, painters that we have become familiar with the colour theory of opposite or 'complementary' colours. A secondary colour (made by mixing two primary colours) that appears opposite a primary colour on a colour wheel can work with that colour in a remarkable way to create visual tension.

When pure red and green, for example, are placed together, one colour appears to push the other colour forward. Another example might be if you were painting a blue wall; this could look quite flat and lacking in interest until a bit of its opposite, orange, is added next to it.

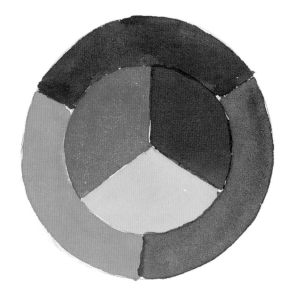

▲ *The basic colour wheel illustrates how the primary colours of red, blue and yellow sit opposite the secondary colours – purple, green and orange – mixed from them.*

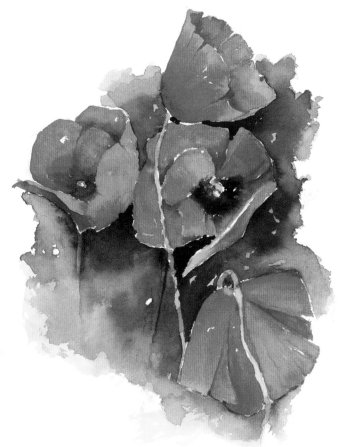

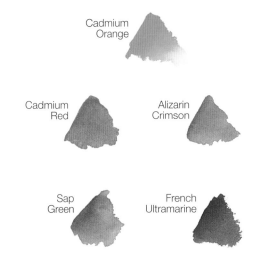

Cadmium Orange

Cadmium Red

Alizarin Crimson

Sap Green

French Ultramarine

◀ *Red poppies against green foliage illustrate clearly how nature puts colour theory into practice. A Cadmium Orange undercoat enriches the Cadmium Red of the petals. The poppy centres were a strong mixture of French Ultramarine and Alizarin Crimson that bled softly into the damp red. The loosely applied background green was a mixture of Sap Green and French Ultramarine applied to damp paper and allowed to bleed freely.*

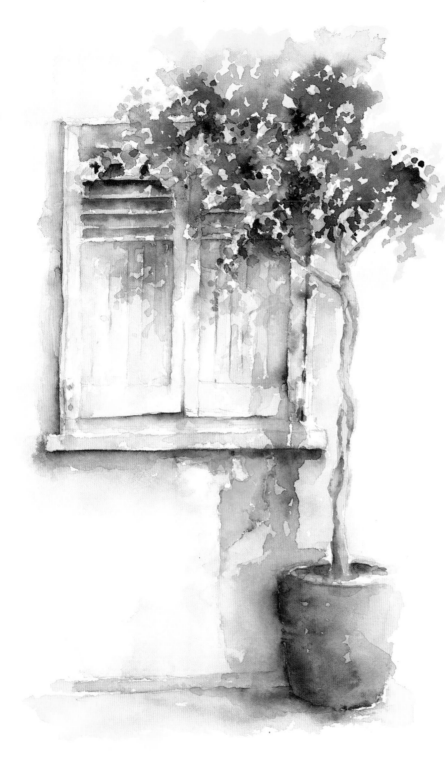

◀ **Provençal Backyard**
30 × 20 cm (12 × 8 in)

It only takes a flash of an opposite or complementary colour – in this case orange next to the pale-blue wall shadow – to create a strong sense of visual tension. Look for small areas of complementary colours rather than overload a composition with too much visual tension.

This would 'complement' or intensify the blue, creating an area of strong visual interest without the need to add any more objects.

Complementary colours are more commonly found in nature – cottage gardens are a prime source, for example – but do look in the man-made world. You only need to add a small splash of a complementary colour on a wall, shutter or gate post to make a picture really come alive with colour.

Greens

Greens are hotly debated colours. Should you mix your own, or is it acceptable to use pre-mixed shop-bought paints? My answer to both these questions is 'Yes'. If you rely solely on paints from tubes you will soon run out of different colours and will quickly become aware of their limitations. If, however, you use only a small selection of primary colours and attempt to mix all your own greens, you will find this practice equally limiting. It is all too easy to mix dull, muddy greens by only using yellows and blues, and to miss out on the fresh, sharp greens that come directly from tubes. These paints, however, will rarely mimic the greens that you will see in nature. So, back to my answer – use both!

Sap Green, for example, is of little use when squeezed directly from the tube, but you can create a wealth of different greens by mixing other colours with it. The same applies to most other manufacturers' greens. Olive Green mixed with Lemon Yellow, for instance, produces a soft, spring-like green ideal for painting a garden full of daffodils. Hooker's Green mixed with Prussian Blue, however, gives a cool green suitable for painting the darker winter garden.

▲ *Leaves have two sides or surfaces that are usually different in tone. Raw Sienna is a good underwash colour for most leaves. A watery Sap Green wash is useful for the main bulk of summer leaves, and French Ultramarine provides the darkest tones.*

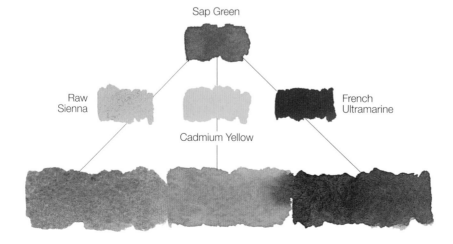

Sap Green

Raw Sienna

Cadmium Yellow

French Ultramarine

◀ *The range of natural colours found in grass, leaves or general foliage can usually be created by mixing various colours with a shop-bought green. Mixing greens with just yellows and blues often results in muddy colours that do no credit to a vibrant summer garden.*

Recording your mixes

My advice, therefore, is to experiment. Mix as many different greens as you can buy and add as many colours as possible to your mixes. It is useful to record the mixes that you make in chart form and keep it with your paintbox, especially those that worked particularly well.

Greens, more than any other colours, are vulnerable to dilution. Many greens change their appearance considerably when diluted and do not simply look lighter or weaker as other paints do. So try to mix the greens you want with a lot of water from the outset to enable you to see exactly what colours or tones you will obtain when the paint dries.

▼ **Garden Pond**
30 × 33 cm (12 × 13 in)

This garden scene involved many mixed greens. French Ultramarine and Burnt Umber created the darkest shadows, while Lemon Yellow suggested the lightest leaves. Very wet paint was used, applied with a large brush. When dry, positive and negative shapes were picked out, working with a small brush onto dry paper.

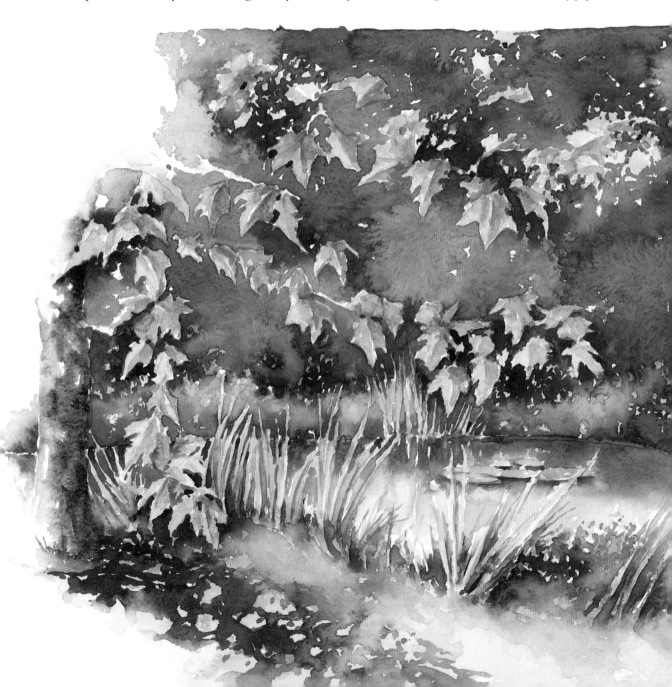

Flower colours

As a painter rather than a botanist I tend to see flowers as wonderful sources of pure colour, providing the chance to use many of the colours – especially reds and oranges – that do not often appear in the fabric of buildings.

Cadmium Yellow makes a suitable starting point for most yellow flowers. It is a warm, strong yellow that will show through subsequent layers of paint applied on top. This is especially useful for establishing the tones of summer flowers. Cadmium Orange can usually be painted on top of this base colour to provide flashes of additional warmth. This is also an effective colour to use for underwashing many red flowers – poppies and geraniums in particular.

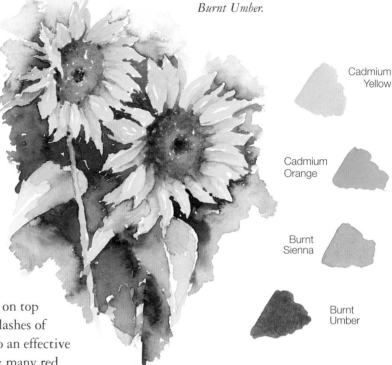

▼ The warmth of these sunflowers is achieved by painting onto a dry underwash of Cadmium Yellow. Cadmium Orange is used to create shadows and to help distinguish the mass of petals. The dark sections on the centre of the flower head are stippled using Burnt Umber.

Cadmium Yellow

Cadmium Orange

Burnt Sienna

Burnt Umber

These flowers need an underwash as the reds used in creating their colours often dry to a very disappointing dull pink if painted directly onto white paper.

Violet or purple flowers often benefit from an underwash of Ultramarine Violet, which can be mixed with Cobalt Blue for a softer, cooler tone. Stronger purple flowers can be painted without an underwash using a mix of French Ultramarine and Alizarin Crimson.

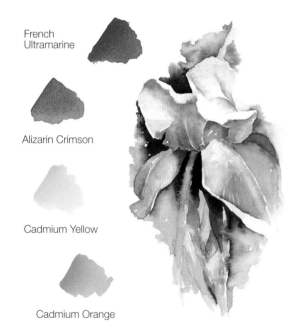

French Ultramarine

Alizarin Crimson

Cadmium Yellow

Cadmium Orange

◀ Irises are delicate flowers that need soft colour mixes. A watery mix of French Ultramarine and Alizarin Crimson is a good starting point, painted onto damp paper to achieve soft bleeds. While the paint is still damp, a touch of French Ultramarine was added to strengthen the mix for the shaded areas.

White flowers

White flowers can be deceptive to paint. Pure white is rare in nature and, as a consequence, white flowers still require some soft toning. While most white flowers will require a little soft colour in parts, if only to indicate where the shadows are, they are probably best created not by painting the flower itself, but by painting what is behind it. By concentrating on the foliage colours observed directly around the flower – usually deep, dark greens that push the flower forward visually– it is possible to make a white flower glow. You can never make the white of your paper lighter, but you can make it appear brighter by making the darks darker.

▼ *White flowers rely heavily on being seen against the dark colours of the background foliage. In this study of white irises Cobalt Blue and French Ultramarine were mixed and applied to damp paper, ensuring that a lot of white paper was left untouched to represent the highlights.*

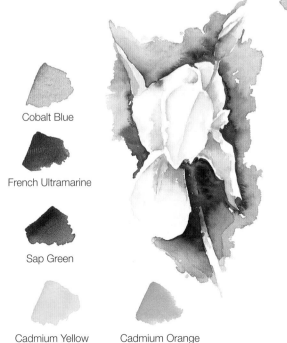

Cobalt Blue

French Ultramarine

Sap Green

Cadmium Yellow Cadmium Orange

▲ *The use of darker tones to create a sense of recession can work with light leaves and branches as well as flower heads. In this study of a country cottage porch the darkest areas were painted last to create the extremes of light and dark needed for a strong painting.*

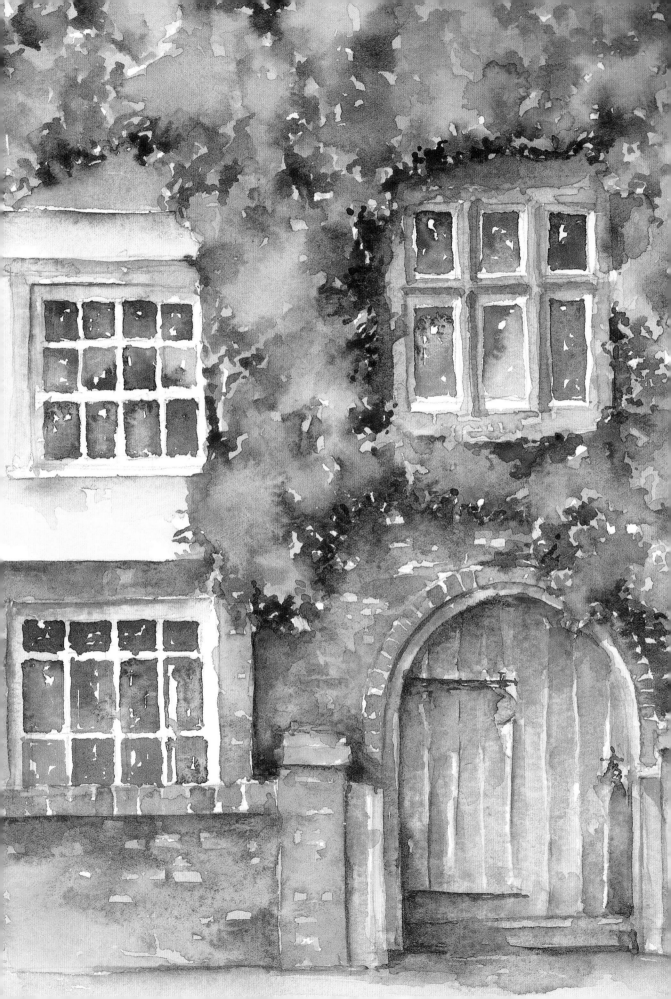

Creating Texture

The very nature of buildings is that they will have a textured surface – whether old or new, of brick, stone, wood, glass or many other materials. All of these surface elements can be recorded in watercolour particularly effectively, utilizing both the qualities of the paper and the physical nature of particular pigments.

This chapter looks specifically at the techniques involved in re-creating crumbling bricks, rotting sheds, stained stucco and reflective glass, and considers the paints that are best suited to the job.

◀ **Brick and Ivy Frontage**
26 × 28 cm (10 × 11 in)

Brick and stone textures

The majority of houses and homes have either stone, brick or wood as their external building materials. These surfaces all have one particular element in common when it comes to recording them with watercolour paint – the specific use of water.

Brick and stone textures can be created by combining a number of watercolour techniques. First, it is necessary to apply plain water to the area of paper where you intend to create an area of texture. The colour is then dropped onto the wet paper using a medium-size brush – Raw Sienna is useful for brickwork and Raw Umber for stone. This paint will immediately run and bleed into the wet paper. Next, choose a slightly stronger colour (this may well be a mix); for brick choose Burnt Sienna, for stone use Burnt Umber and French Ultramarine. Drop this colour onto the now damp paper. Some of the paint will blend and mix with the paint that is already on the paper

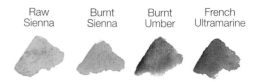

| Raw Sienna | Burnt Sienna | Burnt Umber | French Ultramarine |

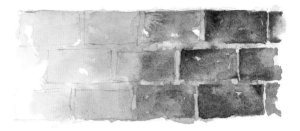

▲ *The textures in brickwork are best created with a free flow of colour and water. Raw Sienna is applied to wet paper and then Burnt Sienna applied unevenly to the paper while it is still damp. This technique creates the basic texture. The shape of the bricks can then be painted onto dry paper to give definition to the wall.*

and some will sit on the water and dry separately as the water evaporates. This will produce an uneven and slightly textured surface that you can start to work onto.

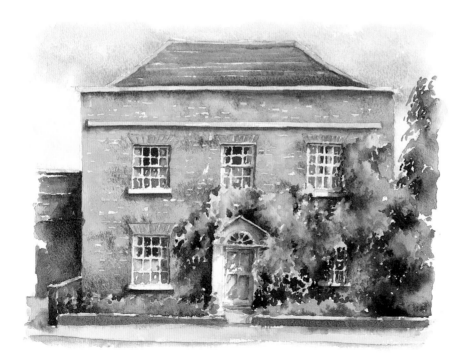

◀ **Georgian House**
24 × 32 cm (9½ × 12½ in)

It is not possible, nor desirable, to paint every brick in a wall, so the artist has to 'suggest' the texture. Selecting a few negative shapes to represent bricks and painting a few specific shapes with a small brush will help to create the required effect.

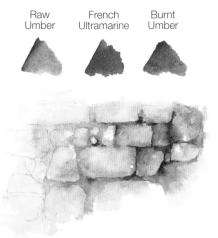

Raw Umber French Ultramarine Burnt Umber

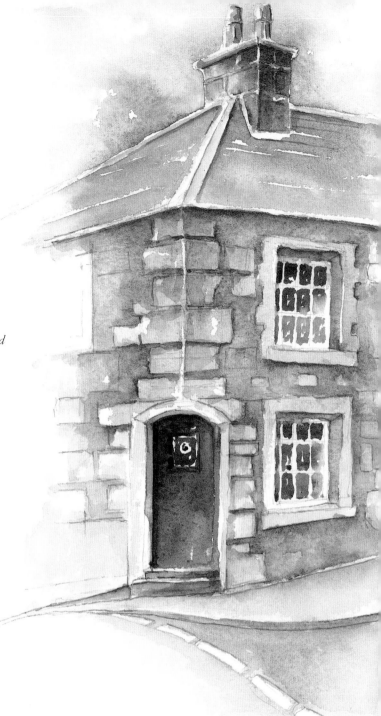

▲ *The principle of allowing colours to run and blend on damp paper is the same for both brick and stone. With stone, however, the shapes are often irregular, usually appearing lighter than the gaps between. Paint the gaps with a small brush and a mix of French Ultramarine and Burnt Umber.*

▶ **Corner House**
28 × 15 cm (11 × 6 in)

Stone buildings can look particularly interesting when viewed from a corner, as the corner stones often create an irregular pattern. A 'flash' of light along the edge of the corner stones adds to the three-dimensional effect; this can be created by either leaving plain white paper or allowing the Raw Umber underneath to show through.

Adding detail

When the paper is fully dry some specific details can be painted to identify the building materials that you are recording. For brickwork you can use mixtures of Burnt Sienna and Burnt Umber to paint individual bricks, leaving the underwash to act as the mortar colour. To prevent the bricks looking too rigid, the process may be repeated at any stage, adding colour to wet paint and allowing it to bleed. For stone this approach can be reversed, 'drawing' the shapes of the stones with a small brush, since the gaps between the stones will often be darker and shadowed. As before, you can drop water on at any stage to improve the appearance of the texture.

Painting wood texture

Wood offers one of the most endearing of building materials for the watercolour painter as it has the potential to take on a wide range of textures, tones and colours, from pristine whitewashed timber cladding to rough and rotting planks.

To paint plain untreated wood effectively in watercolour it is necessary to consider the whole area of wall or section of planking first, before thinking about the details. The area of wood should be dampened with a large brush

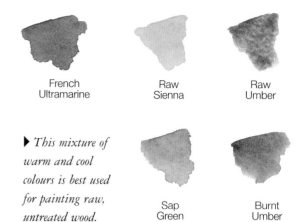

French Ultramarine Raw Sienna Raw Umber

▶ This mixture of warm and cool colours is best used for painting raw, untreated wood.

Sap Green Burnt Umber

and then a wash of Raw Sienna mixed with a touch of Raw Umber applied. This mixture will bleed onto the damp paper and eventually dry, leaving a few watermarks, which are useful when painting textured subjects. When the paint has dried, a darker colour can be added using Burnt Umber with a touch of Sap Green – this mix helps to suggest damp, mould and other qualities of natural wood. Using a medium brush, apply this roughly over the underwash using broken brush strokes, allowing the base colour to show through.

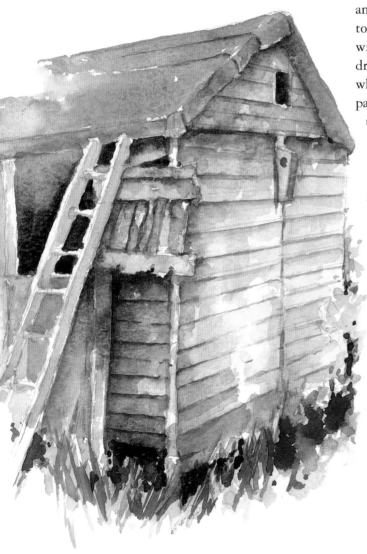

◀ **Derelict Garden Shed**
22 × 18 cm (8½ × 7 in)

The damp found in the wood of old garden sheds requires the addition of blue and green paints to the planks near to the ground.

Painting plank shadows

When the paint has dried, a few of the shadows that occur underneath overlapping planks can be painted in with a small brush and a mixture of Burnt Umber and French Ultramarine.

The idea is to almost 'draw' a line directly under the plank and then 'pull' the paint downwards to graduate the shadow. It is important not to paint all the planks, however – suggestion is the key to success.

◀ The first stage in painting raw wood is to apply a wash of Raw Sienna mixed with Raw Umber. When dry a darker wash of Burnt Umber mixed with Sap Green can be applied, using broken brush strokes to allow the underwash to show through. Finally, a small brush helps to paint a thin line to suggest shadows under the overlapping planks.

▶ Graduated shadows underneath the lower edges of the upper planks show that the planks overlap.

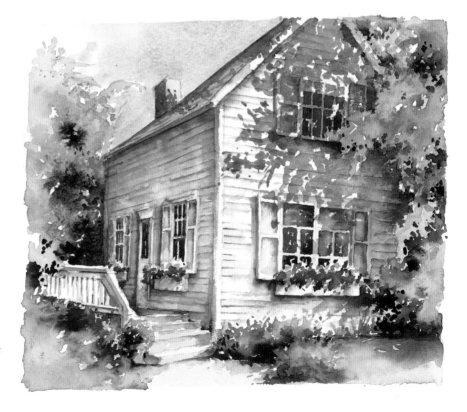

▶ Timber-clad House
23 × 28 cm (9 × 11 in)

Whitewashed wood planking still casts shadows as the planks overlap. Do not try to paint the edges of every piece of wood, but concentrate on achieving a suggestion of the overall look of the fabric.

Painting glass

Glass is one of the most challenging of surfaces to paint as, with the exception of stained glass, it holds no colour of its own and is only visible because of the colours that it reflects.

The key questions to ask before painting windows are what tone and strength of colour should you use? This will depend not only on the time of day, but on the weather. As most of the light reflected from windows comes directly from the sky, it is important to assess which type of sky you have – overcast, bright, or even stormy!

I rarely use Payne's Grey for windows as it contains black, which has the effect of 'flattening' colours, an effect that you certainly do not want when painting reflective surfaces. A neutral grey made of French Ultramarine mixed with Burnt Umber makes a useful basic window reflection colour. These colours work well with windows that often have curtains set just behind them, preventing outsiders from seeing the exact content of the rooms.

▲ **Gazebo**
27 × 20 cm (10½ × 8 in)

Colours viewed through glass take on a muted appearance. To paint these, simply use softer or more diluted versions of the particular colours, painting them around a few flashes of pure white paper.

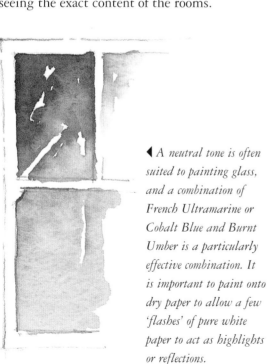

◀ *A neutral tone is often suited to painting glass, and a combination of French Ultramarine or Cobalt Blue and Burnt Umber is a particularly effective combination. It is important to paint onto dry paper to allow a few 'flashes' of pure white paper to act as highlights or reflections.*

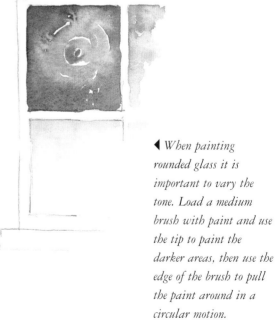

◀ *When painting rounded glass it is important to vary the tone. Load a medium brush with paint and use the tip to paint the darker areas, then use the edge of the brush to pull the paint around in a circular motion.*

Large areas of glass

However, conservatories and larger glazed areas such as greenhouses cannot be painted quite so easily. To achieve the highlights and reflections needed in these cases I advise that you work onto dry paper, painting your chosen tones of grey around a series of white flashes of unpainted paper. Even if you cannot actually see them, they will help to create the illusion of reflected light, informing viewers that they are looking at glass.

Large panes of glass that are not in direct sunlight will allow you to see through them, although any objects you can see will appear a little diffused. The best way to paint these objects is to soften the edges by painting onto pre-dampened paper, giving the impression that you are looking at them through another surface. As is so often the case with watercolour painting, you are not painting the actual glass but the objects seen through it.

▼ **Conservatory**
30 × 28 cm (12 × 11 in)

The structures viewed through glass conservatories, or similar buildings with large areas of glass, are painted in the same way as colours seen through glass. Simply paint a lighter version around white flashes, using broken colour to suggest large areas of glass.

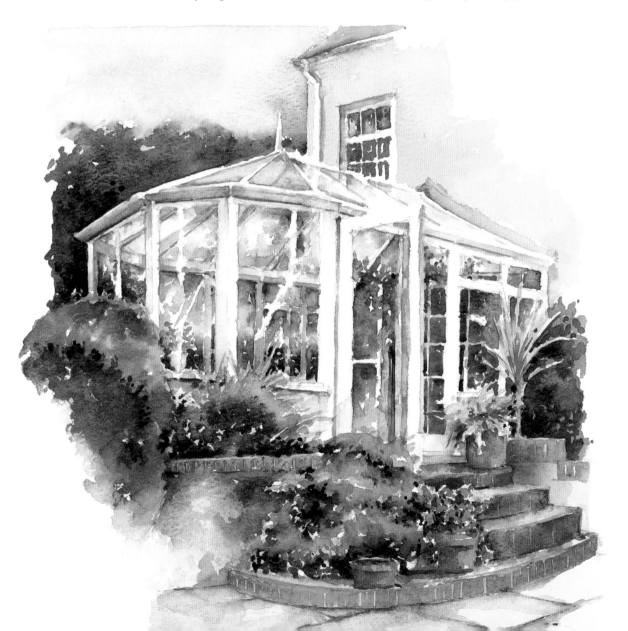

Painting tiles

Painting tiles is not so different from brick or wood. The key difference is that there is probably a greater variety of types of tiles. All tiles are placed in a way that will create some curious shapes and shadows, making a small section of tiles sometimes worthy of a study in its own right.

Pantiles, for example, are particularly popular in warmer climates and create some wonderfully rhythmic patterns as light and shadows fall across their curved ridges. To paint these apply a wash of Raw Sienna across the tiled area using broken brush strokes, ensuring that you leave a few 'flashes' of white paper showing to represent the highlights. Then apply a mixture of Burnt Sienna, again using broken brush strokes to create the bulk of the terracotta colour. For the shadows mix Burnt Umber and French Ultramarine and, working onto dry paper, 'touch in' the darkest areas underneath the tiles with a small brush.

Flat tiles, however, require a slightly different approach. While the colours are similar, only faint shadows can be detected on the tiles' overlap. These are best painted by running a thin line of paint underneath the overlap and 'washing' it gently into the underlying tile.

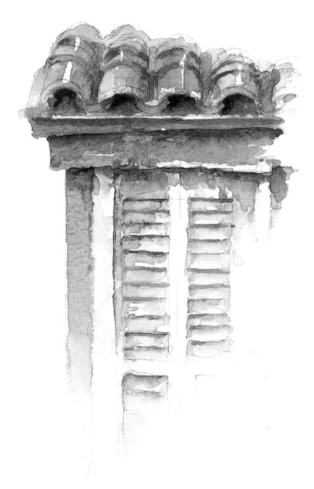

▲ **Pantiles**
18 × 11 cm (7 × 4½ in)

The rhythmic patterns created by overlapping pantiles are always a delight to record. The interplay of light and shadows are their key features.

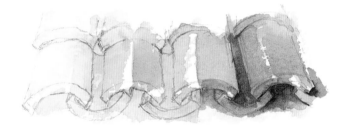

▲ *Raw Sienna is applied to dry paper using a medium brush and broken brush strokes. Next Burnt Sienna is applied – the Raw Sienna underwash will allow this to glow with warmth. Finally, the shadows are picked out with dark paint and a small brush.*

Raw Sienna

Burnt Sienna

French Ultramarine

Burnt Umber

▶ *Flat tiles need a Raw Sienna underwash with Burnt Sienna painted on top once it is dry. The fine lines that visually divide the tiles are created by 'drawing' with a small brush, but do not attempt to paint all the tiles on a wall or roof; just 'suggest' some.*

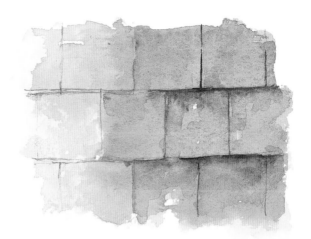

Raw Sienna Burnt Sienna

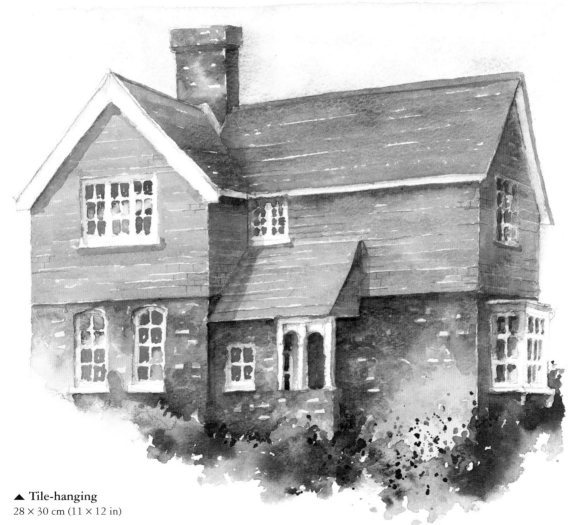

▲ **Tile-hanging**
28 × 30 cm (11 × 12 in)

'Tile-hanging' is a popular and attractive method of covering external walls and allows the artist to create a subtle range of warm sienna tones.

Ageing and weathering

Old ramshackle houses with rusting doors and cracked plaster are often the first choice of the artist to paint, since the ageing and weathering of buildings usually results in visually attractive textures being formed. They make good subjects for exploring the differences between wet-into-wet and wet-into-damp techniques.

Wet-into-wet watercolour painting is, as it suggests, a technique that involves applying watery paint from the palette to watery paint on the paper. Often the paints will separate in the water and dry at different rates. This often results in a watermark occurring; this is a clearly discernible line that distinguishes different tones of paint. In many circumstances a watermark is undesirable, but when painting ageing or weathered buildings this effect can be particularly beneficial. Watermarks can be very useful for suggesting cracks in plaster, peeling rust or uneven surfaces.

Soft effects

Wet-into-damp will result in a much softer effect that can be controlled a little more. This technique involves wetting the paper and waiting until the surface water has almost evaporated, or has nearly dried into the fibres of the paper. At this stage a 'sheen' will appear on the paper. Any paint applied at this stage will bleed outwards evenly from the point where the brush makes contact with the paper. This technique is particularly useful for painting rusty surfaces, or creating mould. Staining is

▼ *Old terracotta pots take on a wonderfully textured appearance after a year or two outdoors. These textures are best created by allowing the physical qualities of the natural earth colours to work for you.*

Granulation *Burnt Sienna and Burnt Umber granulate under the rim of the pot. This effect works best with highly textured paper.*

Watermarks *A hard line or watermark gives weathering. Apply a lot of water, then add paint. A watermark may occur as the paint dries.*

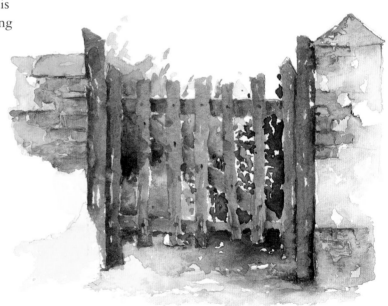

▲ **Rustic Garden Gate**
11 × 15 cm (4½ × 6 in)

A garden gate can be a tempting subject, especially when the wood of the gate is as old and faded as the plaster and brickwork of the posts.

often characteristic of stonework or plaster surfaces. While both techniques remove a little direct control over your paint, they can both be particularly rewarding and are worth experimenting with, especially for these old, weathered surfaces.

Once these techniques have been applied and have dried fully, you can repeat the process. To achieve a particularly stained surface, you can dampen a previously painted sheet of paper and drop wet paint onto this until you achieve enough watermarks or soft stains.

▶ **Greek Garden Gate**
25 × 18 cm (10 × 7 in)

This old rusting gate set into a crumbling wall held a wealth of appealing qualities. The rust was created with a strong mixture of Burnt Sienna onto a dry Raw Sienna undercoat. Dry brush technique created uneven edges to the ground area. A green wash, applied with lots of water, gave a soft, stained appearance to the wall. Cracked plaster was painted with a small brush, running a dark line above the inside edge of the plaster, working onto dry paper to achieve a positive, hard edge.

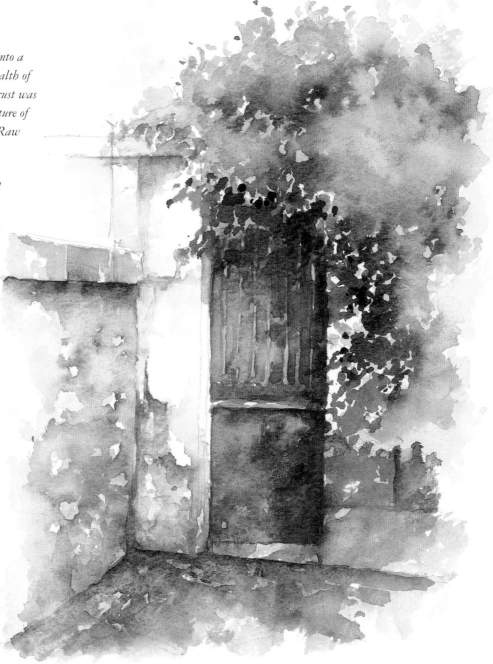

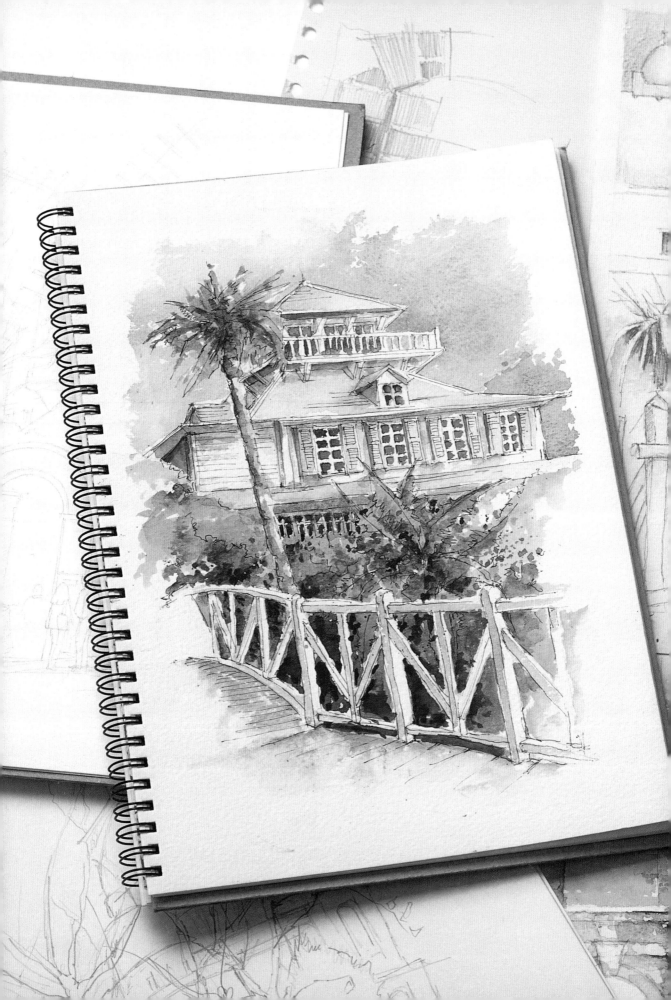

Using a Sketchbook

Sketchbooks are the lifeblood of artists. They allow you to record places you visit and sites you see, and act as a permanent reminder of the colours, shapes and textures that you do not have time to paint fully at the time. They also encourage practice, which cannot be bad!

This chapter explores some of the subjects that you might consider filling the pages of your sketchbook with, as well as looking at the range of media you might use, and illustrates how to turn a small 'thumbnail' sketch into a finished painting by 'squaring up'.

◀ *Richard's hard-backed ring-bound sketchbook, used for making outdoor studies.*

Using watersoluble pencils

Watersoluble coloured pencils are solidified sticks of pigment and gum arabic within a wooden casing. These pencils are highly portable and inexpensive and make an ideal addition to a sketching bag. They allow you to produce quick, instant images that combine both the rigid structure of drawings, yet can be washed across to give soft edges and the effect of watercolour painting.

Watersoluble pencils are also available in grades of graphite, usually light, medium and dark, and can add another dimension to your sketching – pure tone.

An advantage that watersoluble pencils have over standard watercolour pan paints for sketching is that they do not require much water to create a watercolour effect. This means that you can be fairly sure of keeping a 300 gsm (140 lb) sheet of watercolour paper flat without the risk of cockling occurring.

The one particular advantage that watersoluble pencils have over watercolour paints, however, is that they do not actually have to be used with watercolour paper.

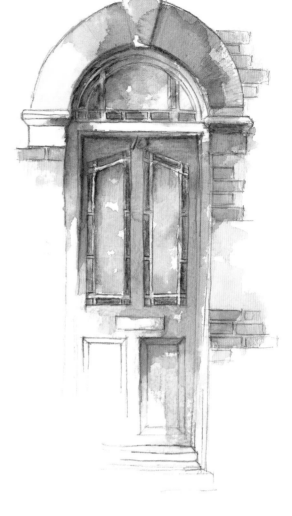

▲ *Watersoluble pencils are ideal for studies of particular features of buildings, rather than full-scale pictures.*

◀ *This shows the effect of applying a watery wash to a series of dry watersoluble pencil marks.*

◀ *Watersoluble pencils can be blended together, but some of the original pencil marks will usually still show through.*

◀ *Drawing directly with watersoluble pencils dipped in water produces rich colour or thick lines.*

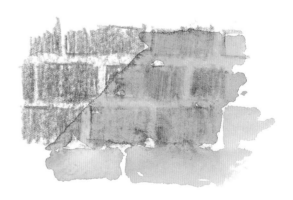

▲ *Brickwork in this illustration was created by drawing the bricks with a Burnt Sienna pencil onto a Raw Sienna base, then washing liberally over with a wet, medium-size soft brush.*

◀ *Washing water across watersoluble graphite pencil usually produces a lighter tone once the water has dried and graphite particles have settled.*

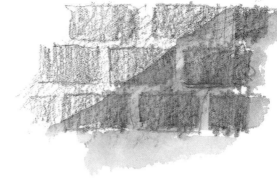

▲ *These bricks were sketched with a watersoluble graphite pencil as with any other graphite pencil, using a selection of angular marks. Water was then applied with a medium-size brush.*

◀ *This shows the effect of drawing directly with a watersoluble graphite pencil that has been dipped into water.*

Although watersouble pencils are probably best worked onto paper with some 'tooth', they can be used to good effect on cartridge paper.

Making small sketches

These pencils do, however, have some limitations. The very nature of pencils is that they cannot effectively cover a large area of paper and watersoluble pencils are no different. They are, therefore, best suited to making small sketches or visual notes of particular features, especially those where a watercolour brush might not be suitable for recording specific details.

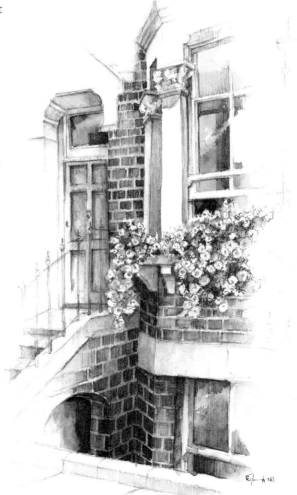

▶ *This suburban house study used watersoluble graphite pencil to emphasize the grainy texture of the brickwork. After the first wash had been applied and allowed to dry, a second set of pencil marks were drawn onto a few selected bricks to enhance their darkness.*

Making building studies

Sketching on site is not easy, but going out with a sketchbook, a pencil and a limited set of watercolour paints is a highly rewarding experience. You can often gain a tremendous number of references in one day's sketching.

The sketches shown on these pages are all homes of people who live in one small village. They were all painted in one day, with constant and fair weather conditions, which is why so many of the buildings look similar in colour. The shadow and brick colours were the direct result of the conditions.

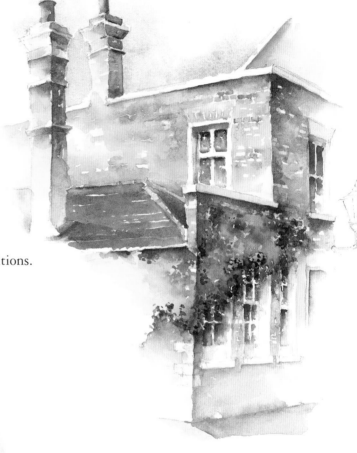

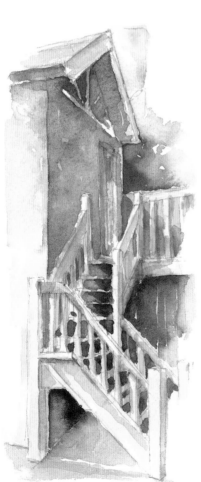

▲ *This study of an ivy-clad corner of a house merged and blended with the stair study as the sketch developed. There is no reason why sketchbook studies should not be a visually appealing juxtaposition of colours and negative shapes.*

◀ *The proportions of this study, dictated by the height of the wooden stairs, were unusual. Long, thin compositions are not usually associated with painting houses.*

▶ *A sketch can help you decide just how much you wish to include in your study. Figures and vehicles can often be a vital part of the character of a district and you will have to make some decisions on what to put in.*

As you can see, the mood of the day did not change noticeably during my sketching period.

These studies are more visual notes than accurate records of a particular home, since I was more concerned with capturing the colours and shadows to use later on for references. In fact, I tend to use these sketchbook studies rather like a selection device, having a go at sketching views or section of houses that look interesting on site. Once back home, the interesting shapes may well stay as just that, and may never be fully developed, but, alternatively, there may be enough material for an entire series of paintings.

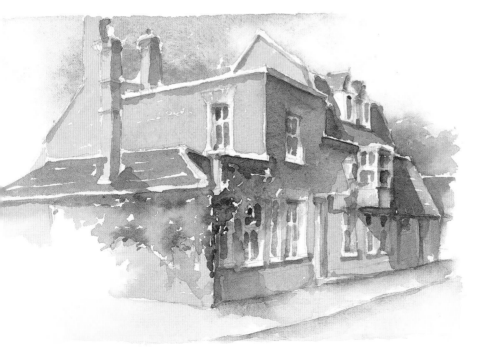

◀ *This sketch helped me decide whether I was going to paint the whole building or just a small section of it, such as the ivy-clad corner.*

Making garden studies

A day spent in a garden with a sketchbook and a small tin of watercolour paints may result in more than just a colourful selection of flower studies. Most gardens hold a variety of features ranging from decorative archways and trellises through to an old rotting potting shed, and many other subjects will turn up.

Many of the illustrations featured in this book are 'accidental still life' studies. These are, simply, subjects that you are likely to stumble across that have not been pre-set or placed together with the intention of creating a visually pleasing collection. They are just objects that have been left standing and perhaps catch the light as you walk past, attracting your eye and jumping out at you. Your sketchbooks should contain a wealth of these subjects.

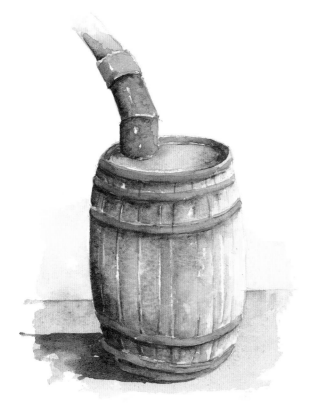

▲ *This elaborate tracery of garden trellis was too much to record as a large painting, and it would not have worked well contained within a rectangle. So I painted only a section as a sketchbook study, although it was actually the green planking seen through the wooden tracery that was painted. The white wood was allowed to take care of itself.*

◀ *The textures on this old water butt made it a very attractive subject for a sketchbook study. The combination of the strong Burnt Sienna in the rusty pipe and the softer tones of Raw Umber in the faded wood combine to make this commonplace subject into an appealing picture.*

Filtered lighting

One of the most enjoyable aspects of sketching in a garden is that you will find a number of textures to experiment with. Wood, terracotta, stone, bark, rusting iron – all are plentiful and worthy of studies. But do not just look outside. Take a look inside the potting shed or where the gardening tools are housed – these are the places where you are most likely to find the accidental still-life groups, usually awash with textures and often bathed in a soft light.

To create this soft, musty lighting that filters through dust-covered windows I tend to use the warm colours – Raw Sienna and Burnt Sienna – for the main subjects, which will usually be terracotta or old iron, and balance these colours with a watery mixture of Ultramarine Violet for the shadows. Although soft in tone, these shadows are often clearly defined and long, since the directional light is clearly visible, coming from one source alone – that old dusty window.

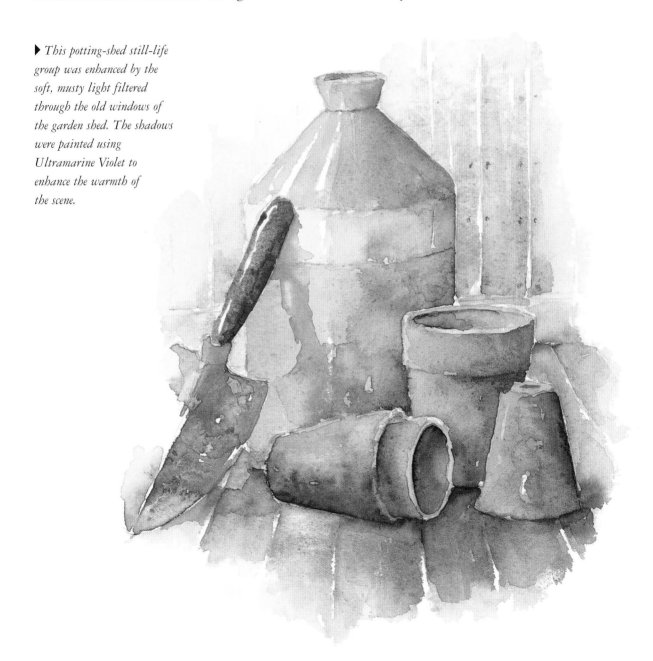

▶ *This potting-shed still-life group was enhanced by the soft, musty light filtered through the old windows of the garden shed. The shadows were painted using Ultramarine Violet to enhance the warmth of the scene.*

Squaring up

You may wish to use an on-site sketch as a reference for a more elaborate study and this will usually involve enlarging the sketch. The term 'squaring up' is commonly used in art schools, but can be rather deceptive as you do not have to use squares! The system simply involves drawing a symmetrical and even grid on top of your original artwork.

Then, when you have decided on the size of paper that you wish to work on, draw an enlarged version of the sketch grid onto this. For example, a small postcard-sized sketch measuring 12.5 × 17 cm (5 × 7 in) could have a rectangle drawn around it and this could be divided into half both horizontally and vertically. The halves could then be halved, creating a grid of 16 rectangles drawn across the sketch.

To enlarge the grid you need to multiply the outside rectangle measurement and construct the new grid on the larger sheet of paper. For example, the original sketch could be doubled in size to create a 25 × 34 cm (10 × 14 in) painting. There is no end to the size of enlargements you can make in proportion to your original sketch.

▶ *The asymmetry of this new surburban house meant that a 'grid' system was particularly valuable. To enlarge particular details you may find it helps to sub-divide one or two of the rectangles, as shown here for the garage area. This will help you to focus more clearly on small areas of detail.*

▼ *Draw a grid across your original sketch. If you do not want to spoil the original you can always use some tracing paper as an overlay sheet and draw onto this.*

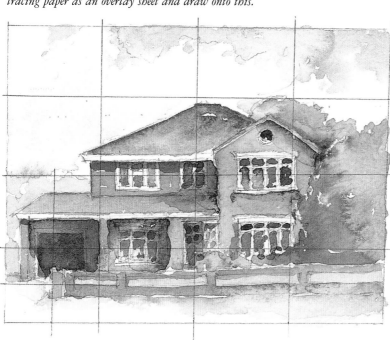

Copying your sketch

Once the grid has been drawn you can then begin to copy the information from each small rectangle on the sketch and transfer it to the new larger grid. But do not forget that this is only an 'aid' to drawing. You will probably want to introduce some freehand drawing once you have plotted the key features. Always remember that any supportive grids or sets of pencil lines are only indicators of where you will place the paint. Allow your painting to move and exist outside of the linear structure.

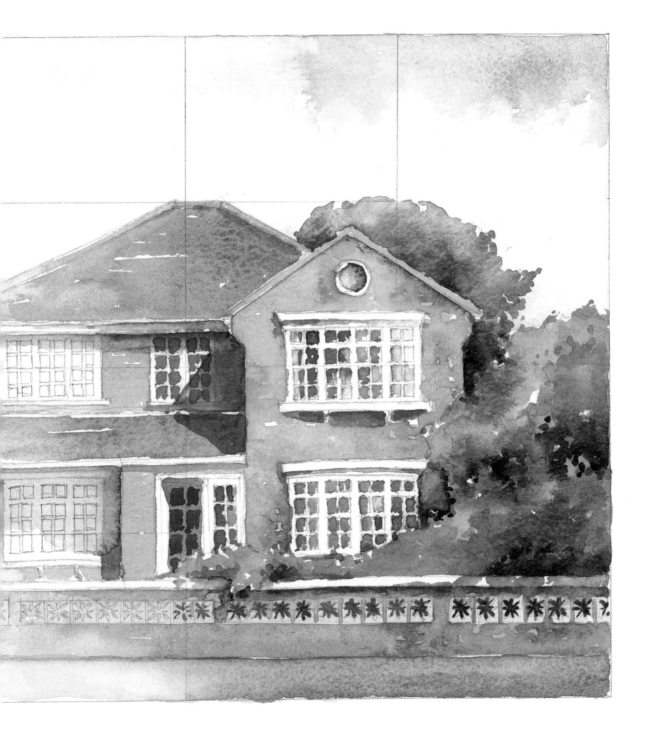

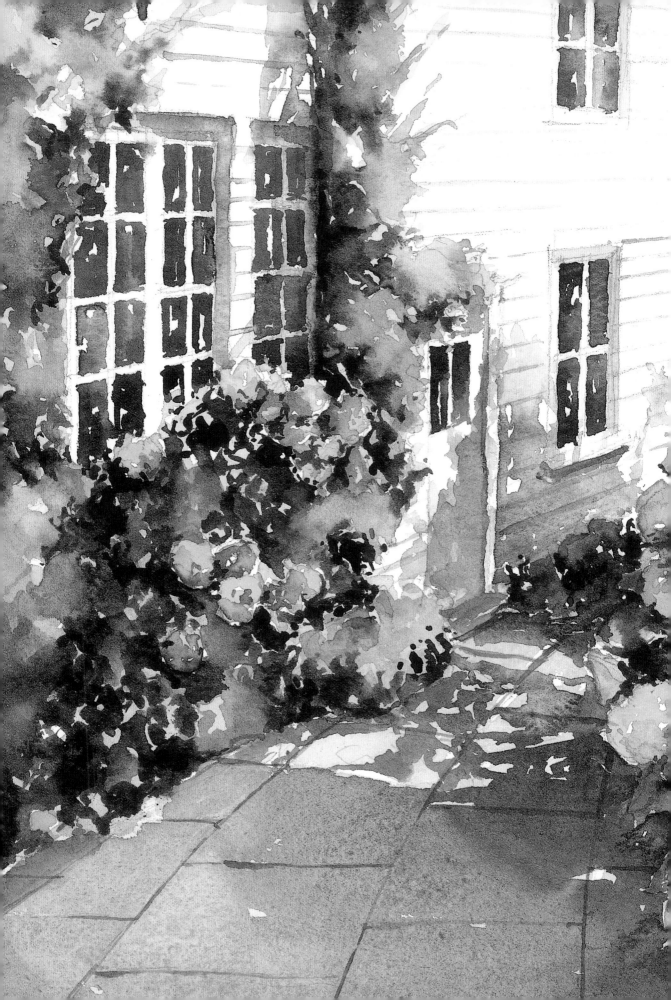

Perspective & Composition

Where to place a house in a painting and how to make it look convincingly solid are related skills, involving both composition and perspective. The concept of perspective is all about illusion – how to create a three-dimensional image on a two-dimensional sheet of paper.

The idea of a 'pleasing' composition, however, is more subjective. So, while some rules and guidelines exist, this chapter is largely about leading you part of the way, offering some skills and some alternatives, then handing control over to you.

◀ **Hydrangea Cottage**
26 × 28 cm (10 × 11 in)

One-point perspective

Everywhere you stand – either in your back garden, or at the front of your home – you can view houses in one-point perspective. Simply look to your left or right and you will see the lines of fences, walls or terraces appearing to converge away from you.

The first stage when constructing a picture in any perspective is to create an imaginary horizon as it is unlikely that you will see one in any built environment. This will represent your eyeline. Anything above your eye will be drawn above this line, and anything below your eye will be drawn below the horizon line, giving you a good conceptual starting point.

Having established your horizon line on your page – one third of the way up is usually a good place – again, imagine a single point off your page where all of the seemingly convergent lines would meet. This is known as the vanishing point. Now consider your building as a box and sketch in the outer shape, ensuring that the top and bottom lines would, when extended, meet at that imaginary point.

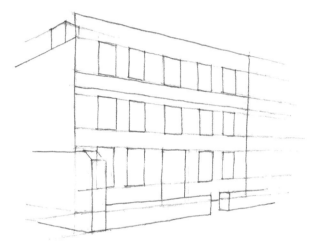

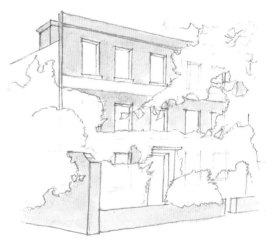

◀ *Establish a pencil drawing to act as a framework. The drawing should act as a guide and not be restrictive. It is important that all lines appear to converge to one vanishing point, and that all vertical lines remain upright. Try to visualize the entire building as one large box, avoiding trees and foliage at this stage, allowing for more fluidity of line.*

▶ *The peripheral elements that make a building become a home are introduced. Draw the surrounding trees and bushes, observing where they obscure key features, working on top of your first linear drawing. As you start to paint, establish the brick colour underwash before the trees and bushes as this will allow you to look 'through' them.*

Developing the structure

Having established the framework, you can now begin to develop the details that give your subject its own individual qualities. The windows of a building, in particular, are important features and they must appear to recede towards the one imaginary vanishing point to look correctly placed.

Once you have established the linear structure in perspective you can start to paint, but you may wish to remove some of your guidelines before you begin. A putty rubber is useful for this as it will 'lift' graphite from the paper without damaging the surface.

▼ **Georgian Town House and Garden**
23 × 30 cm (9 × 12 in)

The lines of the windows and the lines of the wall at the base of the composition lead the viewer's eye directly along the lines of perspective to a vanishing point outside the picture frame.

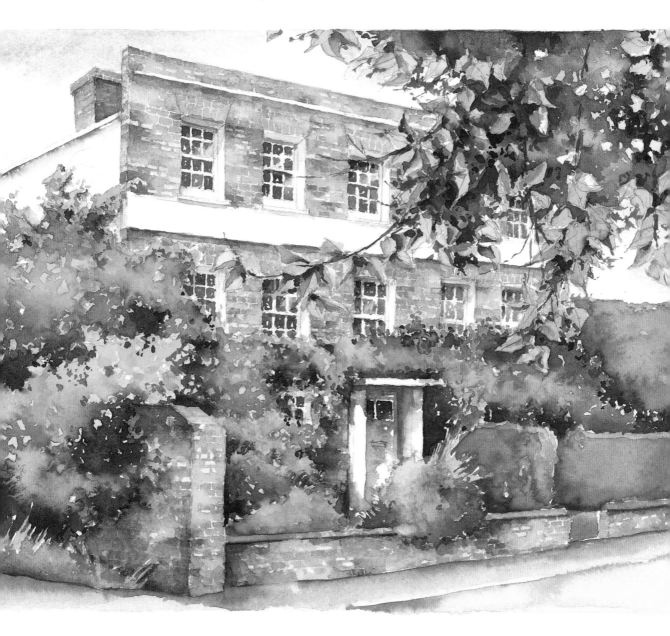

Two-point perspective

This method of constructing buildings uses the same concept of the invisible horizon as one-point perspective, only this time you will need to establish two vanishing points outside the picture frame. Place one to the left and one to the right of your paper, with the corner of your building being approximately one third of the way across. This will help you to create a balanced composition.

Having established the horizon and vanishing points, draw your building as a box, ensuring that both the front and the side appear to converge away from the corner to their respective vanishing points. Extend the lines to these points to help you to establish key features such as the roof, and then put the windows and doors in place, ensuring that they appear to converge accordingly within the constraints of the outer box shape.

Placing shadows

Any superfluous construction lines can now be removed and you can begin to consider the compositon for painting. Now that your 'structure' is in place and the building looks as if it is solid and standing, the perspective can be enhanced by creating a little visual distance.

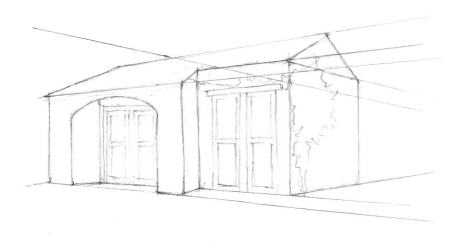

◀ *The line drawing at this preliminary stage needs to show the clear angle that can be viewed from the corner of the building. One set of lines appears to converge to the right of the picture frame, while another set appears to converge to the left.*

▶ *Shadows become more important as you look at the conflicting directions of the lines that create the illusion of two-point perspective. Establish the shape and tone of these early. Shadows may at first appear too strong, but watercolours always dry lighter.*

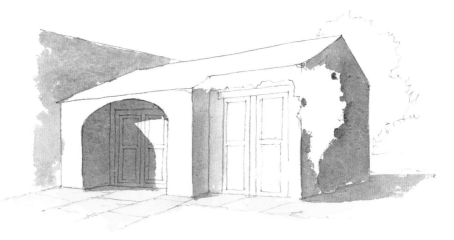

The background, middle ground and foreground need to be discerned, and careful consideration of the shadows can achieve this.

Well-observed and correctly placed shadows will reinforce the three-dimensional effect created by the two-point perspective drawing. Visually, they will send the shaded side receding backwards into the background, and will appear to push the light sections forward into the foreground.

To create particularly strong shadows, I suggest that you start with a strong blue base – French Ultramarine for warm shadows or Cobalt Blue for cooler days – and add the appropriate other colours to these. Paint these onto dry paper to establish any angles or hard edges that you need to support the perspective in your picture.

▼ **Mediterranean Villa and Pool**
23 × 28 cm (9 × 11 in)

The long, hot shadows of the Mediterranean sun serve to emphasize the different picture planes within this two-point perspective composition.

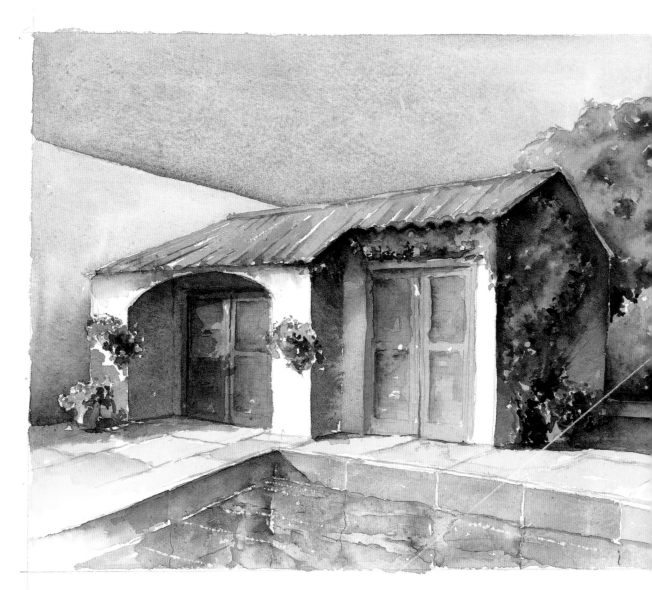

Complex perspective

Many homes, especially older ones, have extensions and additions built on over the years. This can cause a few problems for the artist and, having experienced one-point and two-point perspective, it will only be a matter of time until you are faced with painting a house that contains both of these elements (and many more besides).

In this situation I advise that you give full consideration to 'box construction'. This means trying to see each extension as a box shape.

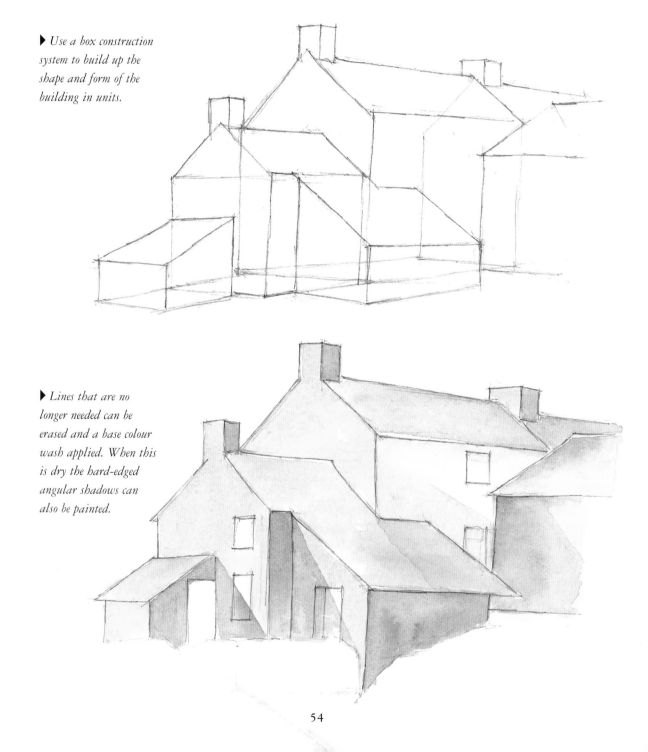

▶ *Use a box construction system to build up the shape and form of the building in units.*

▶ *Lines that are no longer needed can be erased and a base colour wash applied. When this is dry the hard-edged angular shadows can also be painted.*

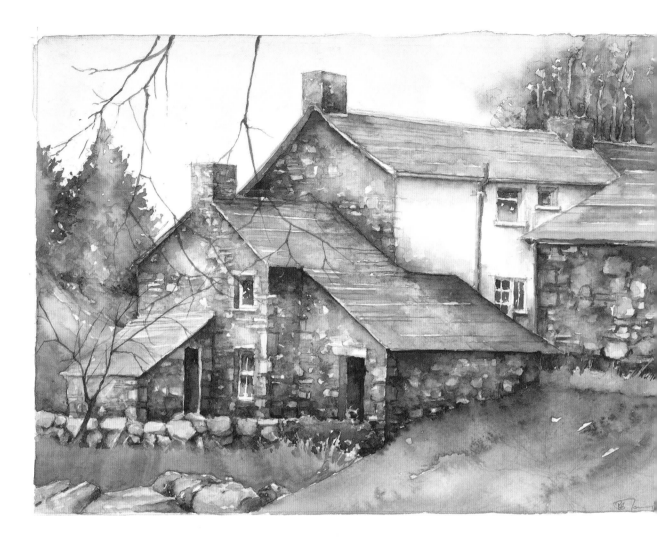

By making each unit a three-dimensional box you will be able to judge each of them on their own perspective requirements. Draw them all as transparent units and you will be able to assess the way in which they fit together around the central 'block' of the house.

Once you have done this, it is a good idea to establish the lines and angles of the shadows fairly rapidly. This will help you to sharpen and describe the lines of the roof and the angles of the extensions and additional buildings.

When the basic drawing is complete the textures and details can be established in the confident knowledge that the house looks as if it is standing upright and the outbuildings are not leaning at an alarming angle.

▲ **Stone Farmhouse**
20 × 29 cm (8 × 11½ in)

The perspective on this old stone farmhouse was enhanced by the sharp-angled shadows. These were painted onto the stone-colour underwash along the line of the edges of the building and then pulled away, using a damp brush, and allowed to dry with hard lines.

Choosing the viewpoint

Some fine homes, rather like the American town house featured on these pages, are particularly attractive from whichever angle you choose to view them. So the decision has to be made – do you concentrate on painting the entire house, or do you focus on one particular section or interesting structural feature and paint that?

It can be quite useful to carry a 35 mm plastic transparency mount with you when you go to find a subject to paint. If possible,

walk around your chosen building subject, holding the transparency mount up to your eye and using it like a moveable frame. Looking through this viewfinder will enable you to evaluate exactly what is in front of you.

I was fortunate to be able to view the entire American home shown here for one painting, as well as being able to move to the right to produce a painting of the steps. The 'front-on' painting shows the architectural features well, but gives the building a rather flat look. The wooden steps, however, cut across the composition in a diagonal direction, adding a little more dynamism to the 'side-on' picture.

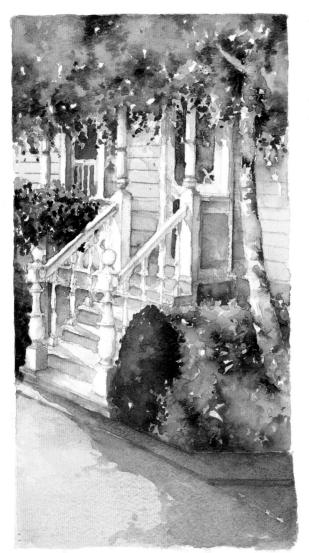

◀ **Colonial Steps**
29 × 20 cm (11½ × 8 in)

This particular view offered some intricate architectural detail and some sharp diagonal lines, making a strong composition. Some studied drawing was required to act as a linear framework to paint onto.

▶ **Colonial House**
36 × 24 cm (14 × 9 in)

The front view gave a much better impression of the house, showing all of its structure and decoration. The result, however, is a less dynamic picture even though it is more informative than the 'side-on' view.

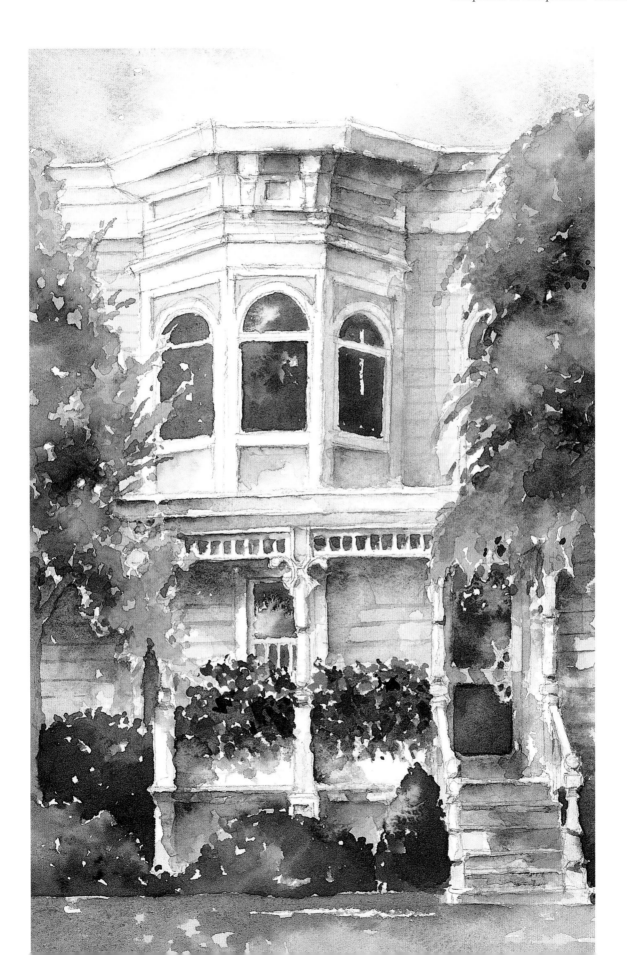

Choosing the format

The dilemma of exactly which way up to have your paper as you think about starting a painting can apply equally in both rural or urban environments. Should you go for a 'portrait' format and paint the one terrace house, or include the whole row in a 'landscape' format, for instance? It is a matter of exploring all the possibilities, and looking carefully at the advantages and likely pitfalls of each.

The first consideration is the purpose of your painting – do you wish to make a study of a particular house and all its individual facets, or are you more interested in taking a wider view, considering the immediate and surrounding environment, and putting the building into its visual context?

If you wish to record the character of the actual house a portrait format may be the most suitable, allowing you to show close detail.

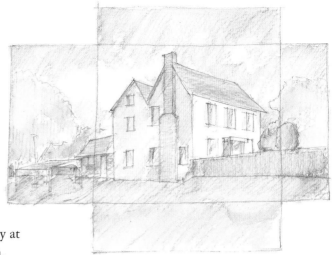

▲ *This watersoluble pencil sketch examined the old farmhouse as both a landscape and portrait format, including as much of the surroundings as possible.*

▼ *This landscape format picture allows the viewer to take a greater overview of the building as it includes the areas to the left and right, and maintains a certain rhythm as your eye is drawn across the picture plane. It does, however, lack the height and visual 'weight' of the portrait format version.*

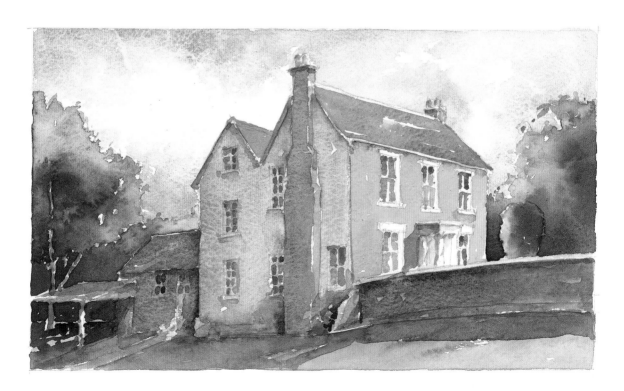

On the other hand, the landscape format is traditionally considered better for including gardens, foreground and backgrounds.

A portrait, or upright, format will allow you to develop several key compositional qualities. It is a little more 'dynamic' in appearance, allowing thrusting vertical lines to inject a real sense of strength into the scene. It also allows you to include quite a large area of foreground – this can be particularly valuable if the house has an appealing section of either front or rear garden. However, this format may restrict any horizontal flow of paint as there is a smaller area across which to move the brush and it can result in a backwards/forwards motion that lacks rhythm.

A landscape, or lengthways, format allows you to include much more of the environment into which the house is set, and will always impart a more passive feel. The visual tension of the portrait format will be lost, but you will be able to paint more fluidly, pulling paint across the length of the paper and producing a painting that is visually more gentle.

▶ *This upright portrait format picture allows the foreground shadow to lead the viewer's eye into the composition right into the strong central image of the building itself. As this does not allow much opportunity to develop a sense of perspective, the building appears to be visually solid and dominates the composition.*

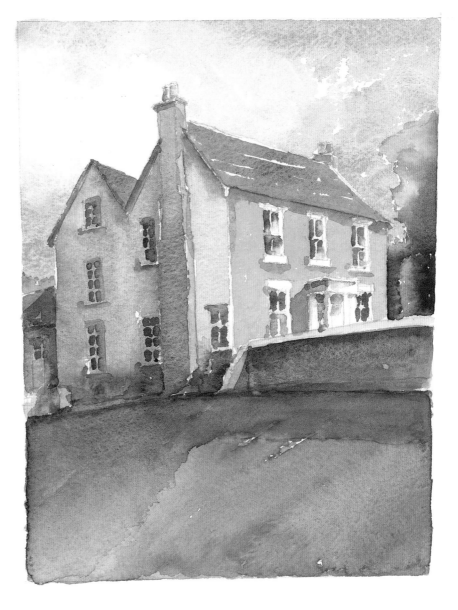

How much foreground?

We are all familiar with the cartoon photographer looking through his lens to find the best composition as he walks backwards over a cliff! Finding the best place from which to paint your house or garden, however, does take some serious consideration. Sometimes you will have little choice as to where to position yourself, and on occasions you will simply find yourself with viewpoints that are particularly limiting.

At other times, however, you will find that you have a choice. So, do you move closer to the building, giving you a clear view of the details and allowing the house to dominate, or do you move back a little, allowing the house to recede more into the middle ground and allow the colours, shapes and shadows of the foreground to make an appearance in your picture and assert their authority? Both have some merit, so why not try a sketch before you make a decision. Or, better still, again use a simple compositional device – a 35 mm transparency mount – to help you make up your mind.

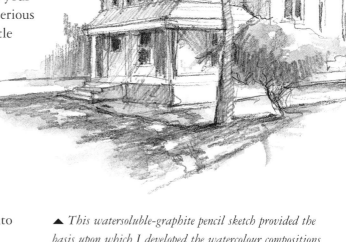

▲ *This watersoluble-graphite pencil sketch provided the basis upon which I developed the watercolour compositions on these pages. I always aim to gather as much information about the scene as possible before deciding the exact size, shape and format of a painting.*

▶ *This close-up painting concentrates mainly on the shape of the house, but includes the key elements of the garden – the foreground tree and bush, and the background foliage. While this type of composition has a clear, central focus – the house – it can appear to be a little compressed and squashed into the picture frame.*

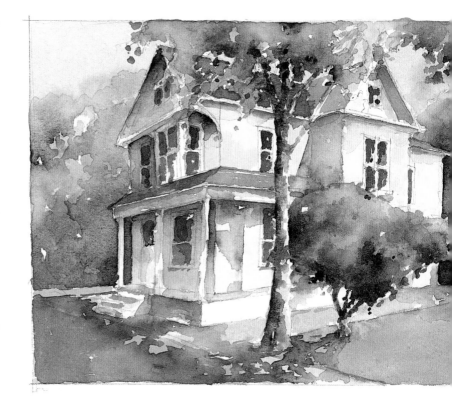

Being rectangular, this mount will probably be proportionally very similar to your chosen painting surface. Hold it at arm's length to frame your scene. This will give you a good impression of how a close-up picture will look. Gradually bring the mount closer to your eye to help you plan how much foreground you might wish to include.

There are a few points worth considering about each of these particular views. A close-up will provide you with much information about your chosen house, but may well look 'chopped off' if the base of the house is painted too close to the bottom of your page. A longer shot,

however, can be useful for leading the viewer's eye to the house, but it can allow flower beds, shrubs, or simply shadows to dominate the composition, leaving the viewer wondering exactly what it is they should look at.

▼ *As this type of long-shot composition has a long visual 'lead in' to the central subject it is possible to introduce a range of compositional devices such as pathways and shadows to guide the viewer's eye to the house. This style of painting also gives greater prominence to the garden, requiring consideration of the tonal difference between the foreground and background greens.*

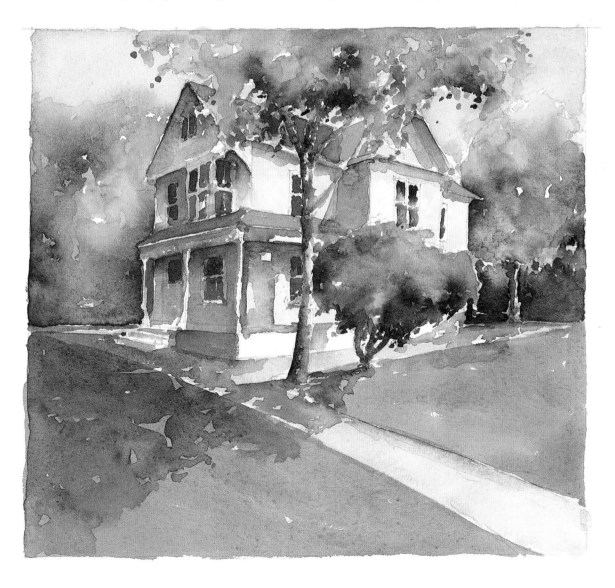

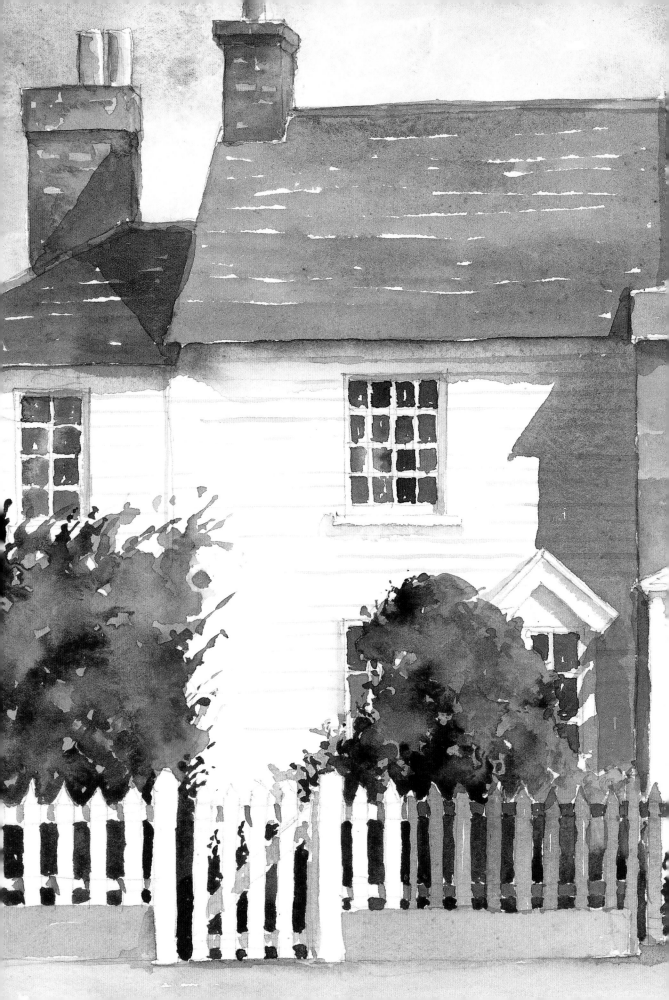

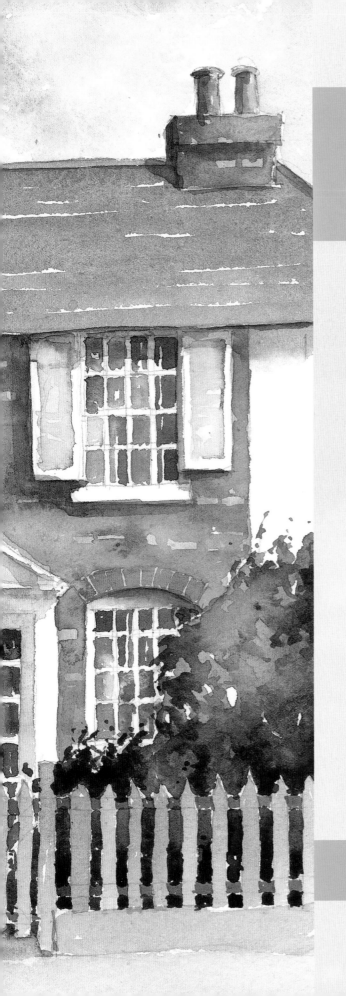

Types of Houses

This chapter aims to bring together all of the elements considered so far — textures, sketch studies, use of key colours, perspective and composition — as it explores the amazing range of buildings that people around the world choose to live in.

But it is not just the structure of these individual buildings that attracts the artist, it is the personalization — flower tubs on balconies, whitewashed walls and twisting timbers — that reinforces the differences that make each house into a home.

◀ **Terraced Cottages**
26 × 28 cm (10 × 11 in)

City dwellings

Traditionally, the type of living spaces found in large cities are likely to be tall, forcing you to look upwards towards the critical area where the building ends and the sky can be seen. If the shapes of the rooftops, or decorative gables that visually punctuate the top of the walls, are complex and compelling to look at you will find that they dominate the composition.

Skies in this type of picture are best limited to a single tone. Too much tone or complexity in this area, scudding or storm-laden clouds or vibrant contrasts, are not suitable as they draw attention away from the rest of the building, concentrating all of the viewer's attention in no more than probably one fifth of the picture frame.

Looking upwards

As you will usually be looking upwards to paint these buildings, you will notice that you are seeing the underneath of eaves and decorative plaster architraves, and these will require some careful attention to ensure that the lines and details are correct.

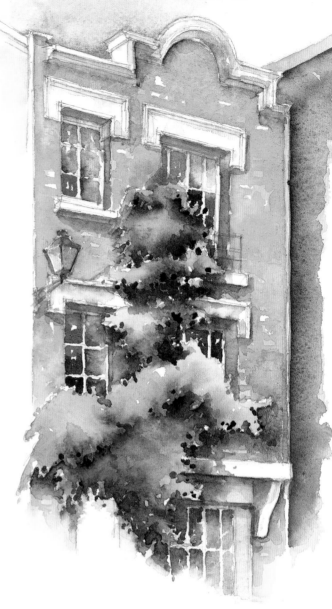

▲ **Dutch Gabled House**
29 × 17 cm (11½ × 6½ in)

The way that the rooftops of this Dutch house were hidden by the gable ends made the building particularly attractive to paint. The decorative plasterwork around the gable and the windows was painted using a hint of Ultramarine Violet and a little Cobalt Blue.

◀ *This study explores the way in which the decorative plasterwork of one particular style of gable 'encases' the brickwork. Look for the way in which the decorative raised sections cast shadows, and run a line of watery dark paint along the inside section.*

It is always a good idea to make a sketchbook study or two of these architectural features to become familiar with their structure before you embark on the main painting.

Finally, it is worth keeping a close watch on your parallel lines. As you sit down to sketch and look upward at a tall building, just as a camera lens does, you may well see an apparent convergence of parallel vertical lines. Try to avoid this or it will make your picture look as if it has been directly copied from a cheap snapshot. This will also add a little more visual 'weight' to your painting with parallel lines leading to a decorative punctuated skyline.

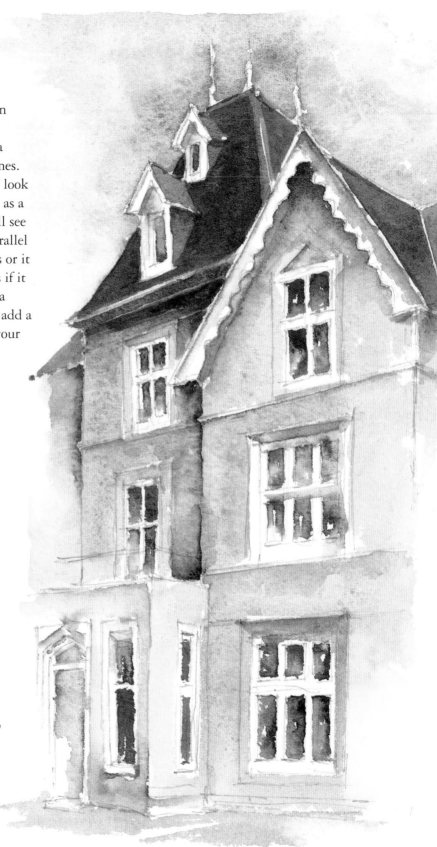

▶ **High-gabled Apartment**
20 × 12 cm (8 × 5 in)

The decorative style of this particular dwelling made the unusual roof a particularly dominant part of the composition. The area directly underneath the eaves was visually important. The strong shadows were painted with a mixture of Burnt Umber and French Ultramarine to make the roof shape really stand out from the walls.

Multi-storey living

The demand for living accommodation in crowded cities has, over the past few centuries, led to a rise in multi-storey living, with new apartment blocks being constructed in urban areas all around the world.

Multi-storey buildings can be wonderful subjects to paint, often because of their exterior eccentricities. Many are old buildings that have been modernized, yet retain their exterior qualities and charm, while others have been 'personalized' by their inhabitants. This will often occur in the form of plant holders, window dressings and hanging baskets. Often these elements are found around the one frequently occurring feature that makes multi-storey living fun – the balcony.

Painting balconies

Balconies, rather like decorative gables, are a real pleasure for making sketchbook studies. You will usually view them from ground level.

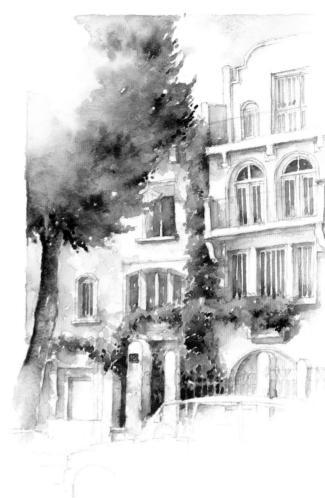

▲ **Parisian Apartment**
33 × 23 cm (13 × 9 in)

This Parisian apartment block would appear flat and lifeless without the balconies. These give the front of the building shape as well as helping to visually define the levels at which the residents live.

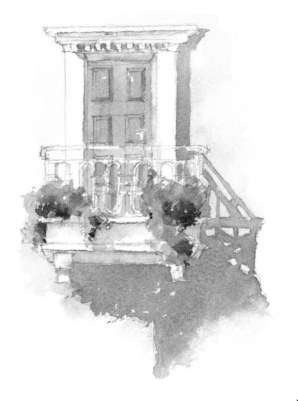

◀ *This city balcony was awash with warm, redolent shadows, painted with a mixture of French Ultramarine and Alizarin Crimson. Hard shadows at the side of the window help to give definition and were painted onto dry paper. Balcony shadows often show an intricate pattern, created by decorative railings. Paint these onto a dry underwash to avoid bleeds and the consequent softening of the image.*

Looking up, you will see the darkest underside of the balcony. This may be the least attractive part of the structure in more contemporary buildings, but can be decorative and appealing on older, more ornate homes.

However soft the shadows cast from and onto balconies are, they are usually best painted using a medium brush, working onto a dry underwash. This helps to provide a sharp area of focus as the paint dries with a hard edge.

Painting windows

The other important areas to consider are windows. To re-create the effect of height, pay special attention to the underside of the tops of window frames. Unless the windows are being lit by reflected light from below (not usual) then the tops will be shaded underneath. Again, paint onto dry paper as a hard-edged line of paint helps to reinforce the architectural feature of a window frame set into the fabric of the building.

The glass itself holds no colour of its own and only reflects the sky or mood of the day. The technique of leaving flashes of white paper showing works well with glass – these small flashes serve to suggest the light reflected from glass and is the purest form of white that can be created in watercolour paint.

With many people living in one building you are likely to find a number of cars on the road, blocking part of your view. Sometimes they form part of the character of the district, so think twice before leaving them out.

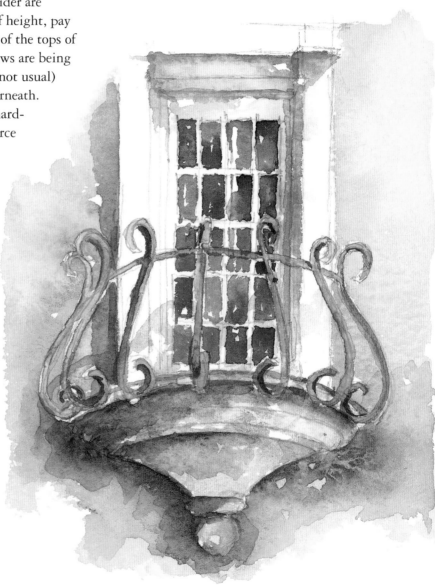

▶ *This Italian town balcony served little purpose other than to decorate the building, which made it all the more appealing to paint. The rust-stained balcony rails were painted with pure Burnt Sienna. Only a touch of Burnt Umber was used to create the shadows.*

Town houses

The idea of a town house as a place for the landed gentry to stay when 'in town' is very much a thing of the past. Yet the designs that were employed in the building of these houses still enhance many towns and cities. Many were based upon the Palladian architectural style favoured during the eighteenth century, a style that can be seen around the world in historic cities such as London, Boston, Milan and Wellington.

From the artist's point of view the key elements of these houses are their symmetry and bow fronts. The symmetrical design is nearly always a feature when viewed from the front, but you may find that the rear of the house is not so symmetrical since extensions and conservatories may well have been added on.

Recording symmetry

To paint these symmetrical buildings you need to consider the final image that you wish to produce. If viewed 'flat on' these are easy to record as you can line up the windows, eaves, doorways and other features. The shadows will be cast regularly, allowing for a simple, angular composition to be developed. But this alone, especially if positioned in the centre of your paper, can look rather flat and uninspiring. The answer may well be to walk along a little until you have a slightly angled view and to paint the house using some of your perspective skills.

Bow windows are frequently found on town houses. They are particularly attractive, but require close observation to be recorded convincingly. If you view them 'flat on' you will need to ensure that they actually look curved. To do this, draw both the top and bottom lines of the window slightly curved. Next, draw the glazing bars, starting with those in the immediate centre. As you work outwards, make sure that the spaces between the bars become progressively smaller. This will make them appear to be twisting slightly, reinforcing the curvature suggested by the top and bottom lines.

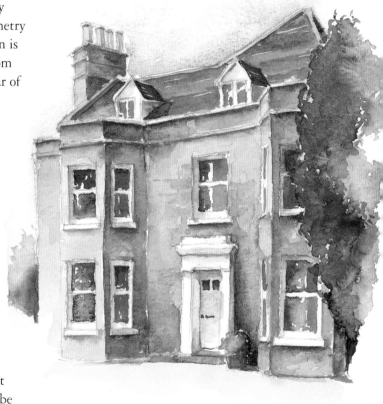

▲ *This detached town house had a symmetrical front with angled bays. The warm brick was darkened in the shaded areas by painting a watery mixture of Burnt Sienna, Burnt Umber and French Ultramarine onto a dry Burnt Sienna underwash. The same mixture was used for the ground shadows, which reinforced the shape of the bays and visually anchored the building to the Raw Sienna ground wash.*

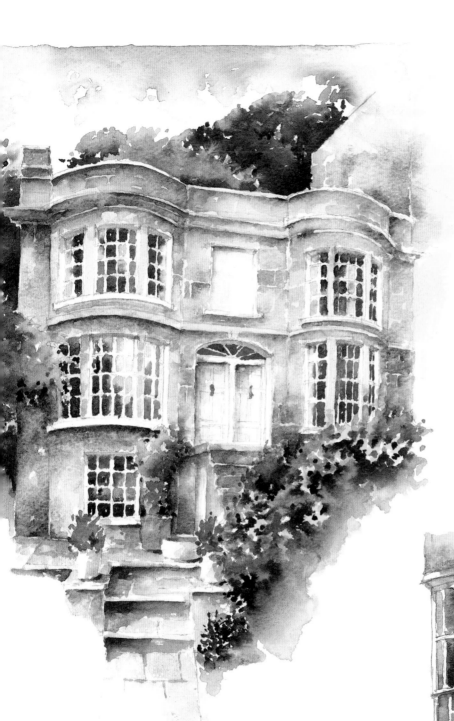

The appeal of this house lay in the curved bays and its double front. As it was set on a hill and I only had access from street level, some manipulation of the perspective lines had to take place to prevent it appearing smaller at the top than the bottom. The curves were reinforced by tonal variations, gradually darkening the shading as the light moved around the shape of each bay.

▶ *Elegantly curved bay windows are always worthy of close observation, especially the way in which the top frame sits above the lower frame. A line of neutral grey paint run directly below the upper frame and pulled downwards onto the lower frame helps to make a window look more convincing.*

Terraces

Terraced buildings sometimes offer you a choice. You can take a step back and paint them 'front on', considering the differences between the individual houses, or look to your right or left and employ perspective.

These buildings come in many forms, ranging from long, elegant neo-classical rows, through to streets of industrial workers' dwellings, with town houses and country cottages in between. The one feature that they have in common, however, is the fact that individual houses are physically joined to each other. This raises a few issues for the artist to bear in mind.

First, many terraces have been built up and extended over a period and different building materials have been used. This makes it fairly easy to punctuate the end of houses as they join the next one in the line.

Second, these types of houses will often have long, joined roofs. This provides an excellent opportunity to practise painting long, flowing lines along the length of the roof. To do this effectively, mix the appropriate colours for the materials used. For tile roofs Raw Sienna and Burnt Sienna usually makes convincing mixes.

▼ **Town Terrace**
24 × 30 cm (9½ × 12 in)

This terraced house was painted on a cool, fresh spring morning. I chose this season as the building would be bathed in cool, blue/violet shadows and not obscured by the foliage from the foreground tree. Cobalt Blue and Winsor Violet (Dioxazine) were the key shadow colours used.

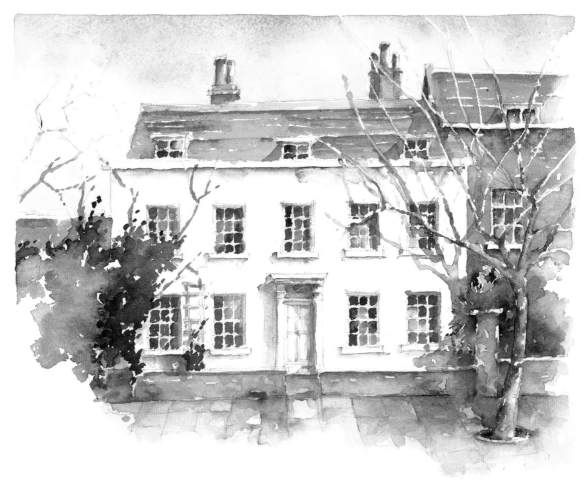

◀ Shadows from dormer windows are often sharply focused at the top and soften as they fall along the lines of the roof tiles. The angle of the tiles on a dormer window will often appear to be quite steep, too, and you may need to exaggerate the perspective to create the right effect. Look carefully at the sides of these windows as they are often of a different material from the tiles on the roof.

For slate roofs you might try mixing Cobalt Blue and Burnt Umber. Then, with a medium-size brush, pull the brush along the line of the roof using the tip of the brush. When you reach the end of the roof lift the brush and start again, below the previous stroke. Repeat this process as you work down the roof, leaving a long line of white paper every second or third brushstroke. The brushstrokes will suggest lines of tiles, with the paper as highlights.

Dormer windows are popular in terraced buildings, and are worthy of painting studies in their own right. Look at the triangular angles that the sides create and the way in which they cast hard-edged angular shadows onto the main roof.

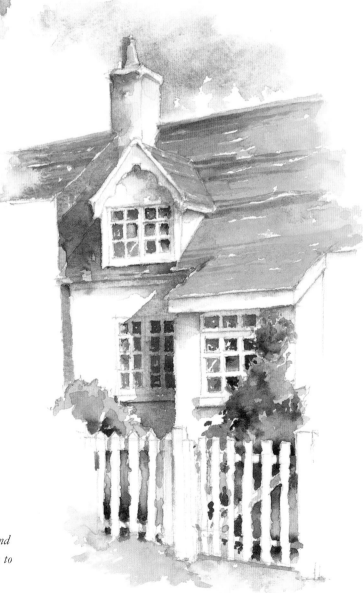

▶ This terrace of rural cottages utilized much warmer shadow colours (French Ultramarine and Alizarin Crimson) to help give sharp definition to the porch and dormer windows.

Timber-frame buildings

Timber has traditionally been used as a construction material for centuries, and these wonderfully picturesque houses are to be found in such diverse locations as Virginia in the USA, Normandy in France, and Suffolk in England.

It is the actual timber frames that usually first attract the attention, because of their powerful joinery and often frightening leans and tilts. Artists, however, soon learn to look at the fabric in between the timbers. Here you are likely to find a range of materials –

stucco or plaster and brick are the most common. One particular feature of the plaster filling found on timber-frame buildings in Britain is the colour – it is often painted a soft pink or a mustard yellow colour . These traditional colours may be easily re-created.

▼ **Timber-frame Cottage**
25 × 33 cm (10 × 13 in)

This old, part-timbered building appeared to defy gravity in parts, with leans and uneven angles being the key visual elements. While this did not affect the perspective, it was quite important to ensure that the vertical lines were not uniform.

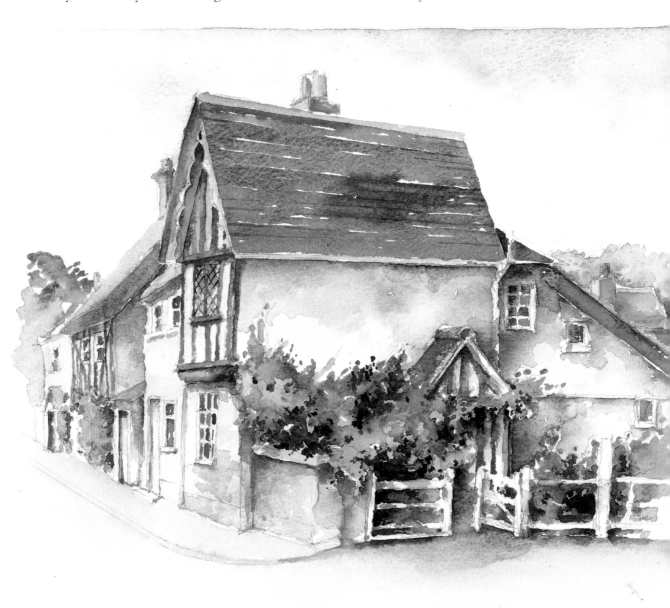

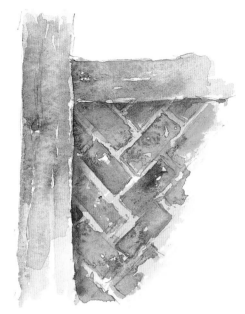

The patterns of bricks can vary considerably, especially if they are likely to be very old, as with this herring-bone brickwork. Old timbers are not always even, and some will cast shadows. To paint these add Cobalt Blue or French Ultramarine to the basic wood colour and apply to damp paper to create a soft bleed.

The pink colour can be re-created by mixing a slight touch of Cadmium Red with a very watery mixture of Raw Sienna, while the yellow can be produced by mixing Raw Sienna and Raw Umber. To create the best effect (these are invariably old, weathered coverings) apply these paints to damp paper, using a lot of water and allow to dry unaided.

While a standard brick colour is a mix of Raw Sienna and Burnt Sienna, look out for the older, burnt bricks and add Burnt Umber and French Ultramarine to the brick colour.

Painting the timbers

The timbers themselves also require close attention, as they are not always what they might seem at first glance – wood is not necessarily brown. Faded and weathered wood can take on a grey appearance, bordering on black at times. I usually paint these timbers with a watery mixture of Raw Umber and Cobalt Blue; this produces a pale, yet warm, grey, which I always apply to dry paper. This allows an element of texture to be introduced as the brush is pulled along the line of the grain, leaving a few flashes of white paper showing through.

▲ The wood of this heavily timbered town house in Normandy had been exposed to the elements for several centuries and had clearly warped and twisted over the years. The texture of the wood grain is created by leaving small flashes of white paper. Notice that timbers are often of different, faded tones – and you will need to create a variety of mixes from a basic palette.

Thatched houses

Thatch is one of the earliest of roofing materials. Visually appealing, it is an enduring and charming material with a fairly predictable colour base.

Thatched cottages are more likely to be found in rural settings, perhaps surrounding a village green. Thatching is a dying countryside craft, however, and many old thatched roofs are being replaced with tiles. The thatched homes that remain are a true pleasure to paint, both for their character and for the settings in which they are most often found.

Painting thatch

Most thatched roofs are best painted with either a Raw Sienna or a Raw Umber base colour, depending on how new the thatch is (Raw Umber is better for older, sun-bleached thatch). Unlike other roof coverings, thatch is best painted onto damp paper. First, dampen the roof area evenly with a large brush and allow the water to sink into the paper until all of the surface water is no longer visible – just leave a few flashes of dry paper around the edges or corners. Then, load a medium-size brush with the appropriate paint of your choice and pull the brush along the line of the roof, but underneath the thatch crown at the top. The paint will begin to bleed evenly into the fibres of the damp paper. Continue to pull the paintbrush across the roof using the side of the bristles to ensure a wide, even stroke. When you have covered the roof (except for the crown) allow the paint to dry.

Next, mix a more watery version of the original colour and, using a small brush, paint the crown onto dry paper. This will dry lighter than the main part of the roof, giving the

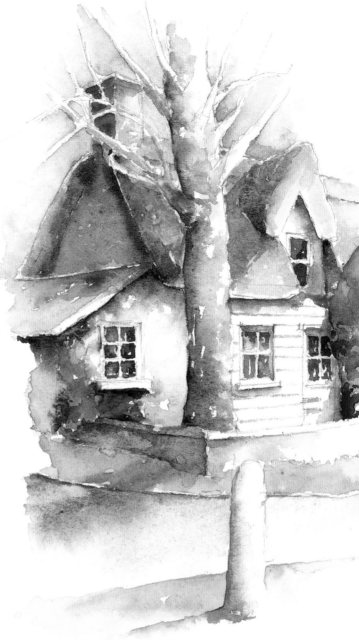

▲ **Corner Cottage**
24 × 15 cm (9½ × 6 in)

The granulation on this thatched roof was created by dropping a strong mixture of Burnt Umber and French Ultramarine onto a very wet underwash of Raw Sienna and allowed to dry without any interference.

thatch a sense of height. Finally, mix a darker version of the thatch colour by adding Burnt Umber and a touch of French Ultramarine and, using the same small brush, 'draw' the shadows cast by any decorative thatch layering to complete the roof.

▶ *A study of a thatched roof will help you to understand its construction. Apply a basic Raw Sienna wash onto dry paper, leaving flashes of paper to suggest highlights. The 'crown' usually casts a shadow onto the main thatch; add Burnt Umber to the basic wash to paint this. Slight shadows occur directly underneath the binding that 'sews' the crown onto the roof. Paint these with a small dry brush, then pull the paint downward with a damp brush.*

▼ **Village Green**
27 × 36 cm (10½ × 14 in)

Much of the texture of the thatched roof in this study was created by granulation, the result of pigments drying into the watercolour paper and separating. The tiny particles can be seen in granular form, aiding the impression of a rough surface. This looks even more effective on highly textured paper.

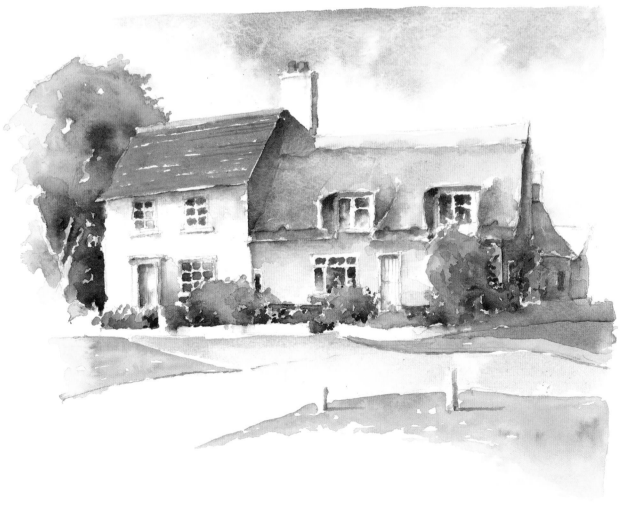

DEMONSTRATION *Townhouse Terrace*

The range of textures that could be seen in this small town terrace was the main reason for choosing this subject. The way in which the bricks, tiles and stones have aged over the years has made the building particularly conducive to watercolour painting. The other reason was the richness of the sienna tones, making the scene almost glow in the bright sunlight.

Palette

Raw Sienna
Burnt Sienna
Burnt Umber
French Ultramarine
Alizarin Crimson
Cadmium Yellow
Sap Green

The very nature of the structure of these buildings necessitated a strong line drawing, ensuring that the symmetry of the central house was in place. When I had completed this I applied a wash of French Ultramarine to dry paper to create the sky.

1

2 Next I mixed a wash of Raw Sienna and Burnt Sienna for the roof tiles and brickwork and applied this with a medium-size brush, still onto dry paper. The tension created as a loaded paintbrush is pulled across dry paper results in tiny flashes of white paper showing through at the end – these are invaluable in suggesting highlights that add life.

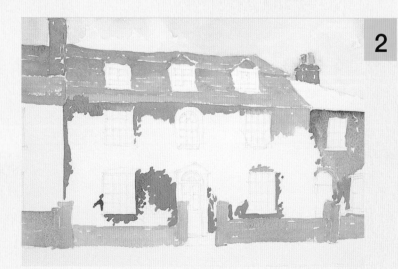

A 'base' colour of watery Sap Green and a touch of Cadmium Yellow was painted onto the ivy area. While this was still wet, I dropped a darker mixture of Sap Green and French Ultramarine onto the shaded areas and allowed it to bleed into the lighter green.

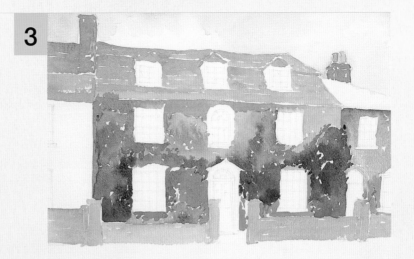

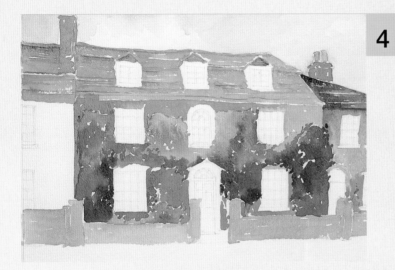

The slate roof of the building on the far right was painted with French Ultramarine mixed with a touch of Burnt Umber. I used the edge of a small brush for this and dragged it horizontally across the roof, leaving 'breaks' in between the lines to suggest the rows of slates.

As it would not have been possible to have added in every brick, I painted a few selected areas to suggest brickwork. This involved making a few marks in Burnt Sienna and Burnt Umber around the window frames and doorways, providing a few bricks for the eye to focus on, but not enough to over-saturate and visually confuse the scene.

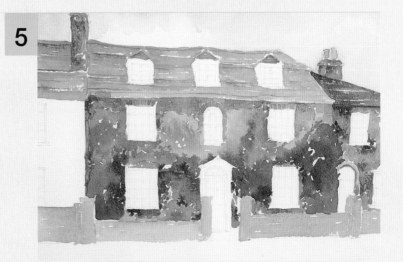

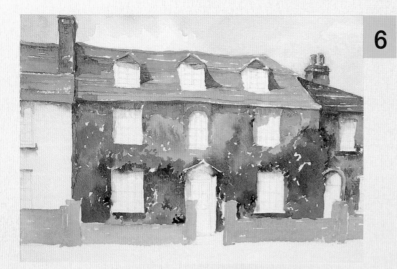

6 With the brickwork successfully 'suggested', the shadows could be painted to make the architectural features such as the doorway and dormer windows appear to stand out. I did this with a small brush and a strong mixture of French Ultramarine and Alizarin Crimson.

Then I decided to enhance the shadows on the ivy. As the green paint had fully dried, the deep violet colour could be painted on with a small brush. I used the point to describe more precisely the areas of extreme shading.

7

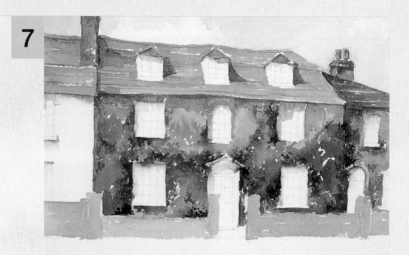

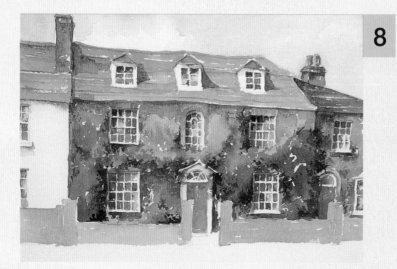

8 The windows needed to capture the brightness of the day. Using a small brush and a mixture of Burnt Umber and French Ultramarine, I painted the window panes, leaving the glazing bars as negative shapes and ensuring that several panes were of a lighter tone than others in the same window.

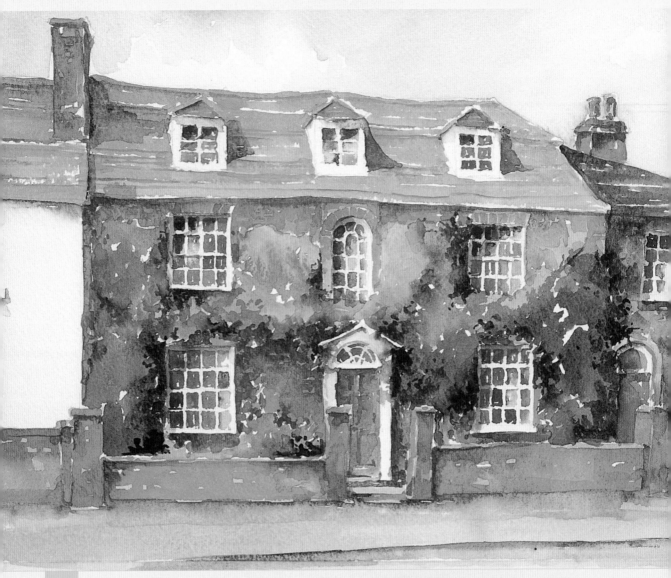

9 **Townhouse Terrace**
24 × 36 cm (9 × 14 in)

It was important that this painting was unencumbered by small brushstrokes that would remove life from the house. Much of the detail was created by allowing watery paints to bleed into each other, drying with a hard edge to suggest brickwork or lines of tiles.

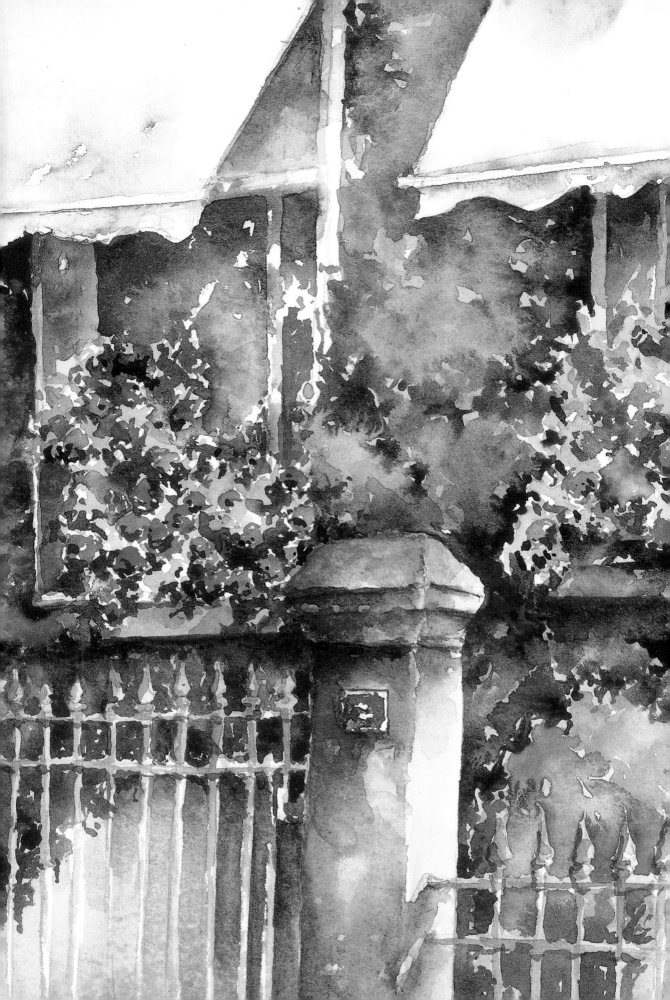

Features & Details

It is not unusual to stumble upon a particular feature of a house that stands out so much that you simply have to ignore the rest of the building and paint that single feature alone. It might be the old shuttered windows on a stone farmhouse, a whitewashed picket fence, an elaborate moulded doorway, or even the shadows created by a fire escape on a city apartment block.

All of these features hold a great deal of potential for exploring and recording in watercolour.

◀ **French Windows**
26 × 28 cm (10 × 11 in)

Doorways and thresholds

Front doorways can be ornate, sometimes elaborate, often seeking to reflect the affluence of the home owners. Walk around to the rear of the house, however, and you may find a much simpler, but no less attractive, doorway.

The one architectural or structural element that nearly all doorways share is that a frame will be set into the fabric of the building, and that the door will be set into the frame. This creates a three-part structure – wall, frame, door – with each set back a little, creating a specific order for shading. Following this order will certainly help you to develop a three-dimensional look to your paintings, and prevent you painting doorways that appear to be flat or 'stuck on'.

Painting a doorway

First, paint the fabric of the building, working around the shapes of any white woodwork or plaster decoration that you can see on the frame. Then use a small brush to create the shaded area where the wall recess meets the doorframe. Paint a dark mixture of the wall colour onto dry paper to create a hard line that will represent the corner of the recess. Finally, choose the shadow colour for the effect that you wish to record, and run a line of this mixture around the inside of the doorframe.

▲ In this study of a cottage back gate the stone surround provides the main interest. The 'head stone' or 'lintel' contrasts visually with the textures of the smaller stones in the wall – some light flashes of paper suggest the highlight on the corners of these stones. The stronger the shadows, the more pronounced the door surround will be.

▶ A fanlight viewed front on is easier to draw, but provides more of a challenge to paint, as the recesses have to be suggested by the use of tone alone. To create a three-dimensional sense of recession, use a small brush to run a line of paint directly underneath the brickwork, observing closely the direction of the light. Make sure that this paint is washed out as the shadow on the curve gives way to light.

▶ **Colonial House Doorway**
30 × 19 cm (12 × 7½ in)

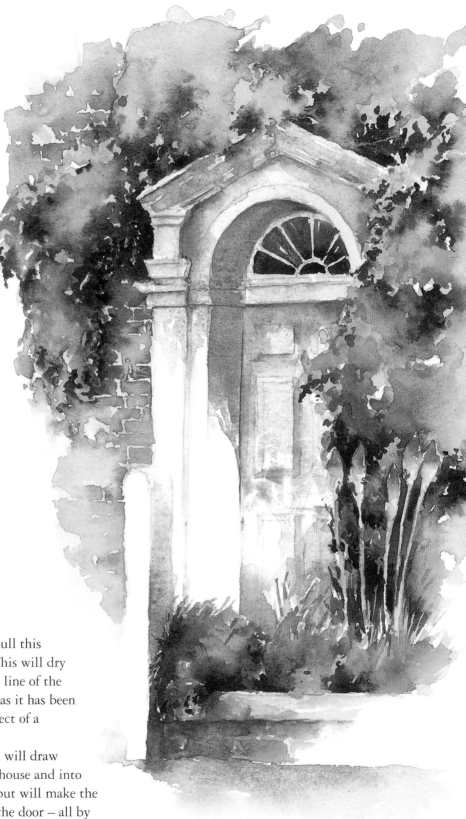

*Doorways can be given a little
more definition if approached
from an angle. While this
provides a few problems
when lining up the inset
windows, it is easier to
paint the shadows that often
fall at sharp angles,
helping to draw attention
to the doorframes. The
recesses of doorframes
often hold the darkest
shadows. Fanlights can
produce some challenging shapes
to record from an angle, so
reinforce the shapes at the top of
the recess with deep shadows.*

Before it has time to dry, pull this
line down onto the door. This will dry
with a hard edge along the line of the
doorframe, but will soften as it has been
pulled away, giving the effect of a
shadow cast onto the door.

This 'system' of painting will draw
the viewer's eye across the house and into
the recess of the doorway, but will make the
frame stand forward from the door – all by
careful use of light and shade.

Steps and stairs

Many homes are adorned with steps leading to the front doorway. Often these will be a few short steps. Sometimes, however, stairways can rise to first or second floors, twisting on their way. Most sets of stairs have sharp, clear-cut angles, which make them fairly easy to paint, although they are not always so simple to draw in perspective.

It is particularly important to establish the line of the top step and the bottom step, ensuring that they appear to converge in line with the rest of the building. Then draw the correct number of perspective lines (to represent the top of each individual step), ensuring that they converge accordingly between the two outer edges. To complete the 'structure' make sure that the downward pencil marks for the edges of the steps are parallel to the edge of the paper – unless, of course, you want uneven and irregular steps.

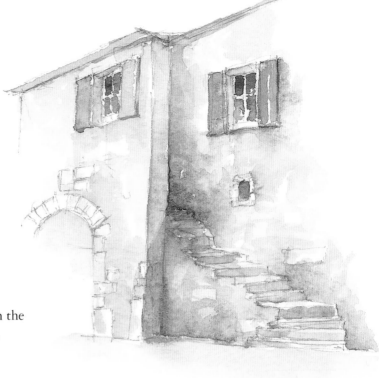

▲ *Large stairways are really only extended versions of small urban doorsteps. In this study of stone steps the area where they appear to end is darkened to visually punctuate this section. A contrast between the light 'top' and the darker vertical blocks of stairs is the key to creating a three-dimensional effect.*

Painting steps

Having drawn a solid set of steps, they need to be painted convincingly. First apply a wash of the appropriate colour (I usually start most steps with a wash of Raw Sienna), with a medium brush, working onto dry paper. Leave a few flashes of white paper along the edges of individual steps to suggest highlights. These should not be regular or contrived – they are a little artistic 'trickery' to visually reinforce the three-dimensional effect.

▶ *Steps are difficult to paint 'front on', so it is always best to position yourself at an angle to your subject. Also, they are often surrounded by a wall either side – use strong shadows to strengthen these, sandwiching the steps in between and making them the centre of focus.*

▶ **Suburban Doorsteps**
32 × 19 cm (12½ × 7½ in)

*Steps always have an
interplay of light and
shade. These steps were
painted with pure Burnt
Sienna and when this had
dried a little Burnt Umber
was added and painted along
the edge of the steps to
reinforce the three-dimensional
effect. When dry, a mixture of
French Ultramarine and
Alizarin Crimson was
applied for the angular
shadows.*

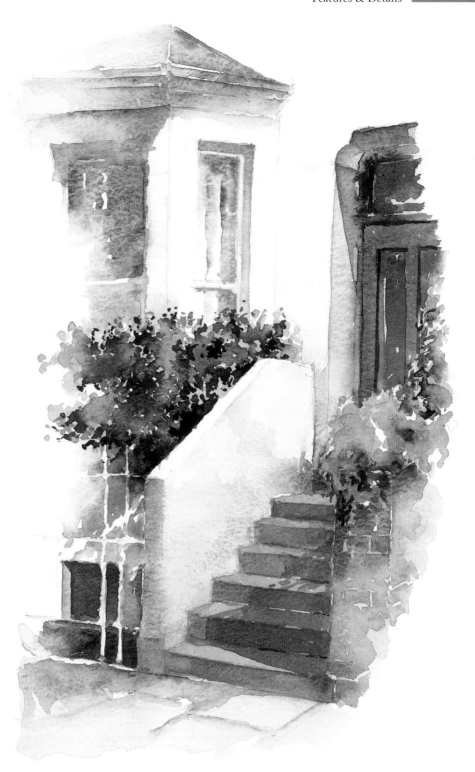

Once the paint has dried, the next stage is to paint the side of the step a darker version of the top colour to help create the sense of height as your eye travels from the bottom step, up through the 'dark, light, dark, light' shading, up to the doorway. Finally, steps are often contained by walls on either side. Any shadow cast by these should be 'drawn' along the lines of the steps using a small brush, and left to dry without any further applications.

Windows

Windows are often seen as the 'eyes' of a home, sometimes allowing outsiders a brief glimpse of an interior, but more often presenting curtains and blinds to the viewer. They share many structural qualities with doorways, being nearly always set into a frame that is usually set back into the fabric of the building.

Windows do not, however, provide so many opportunities for elaborate decoration as doorways, but they are frequently more personalized. Shutters, window-boxes, curtains and so on all serve to make the windows seen in one house very different from those in the house next door.

Painting windows

The principles for painting the basic structure of the window frame set into a wall is exactly the same as that described for painting a doorway on pages 82–83. The key differences are in the details.

When painting 'French windows', for example, it is necessary to look for the centre line where the two windows meet when closed, and the hinges that attach the window to the frame. On older houses a few rust bleeds can be detected, which will contribute much to the character of the house when painting.

Sash windows, however, will need close observation of how the top frame overlaps the lower frame. Careful placing of a shadow directly underneath the top frame will create the visual effect of pushing the lower frame back a little, and pulling the upper frame forward a bit.

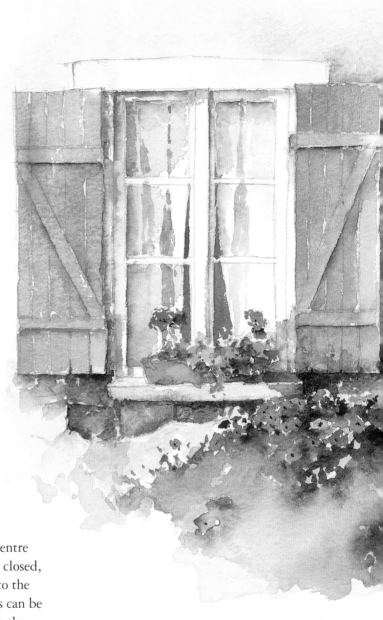

▲ **Brittany Country Cottage**
27 × 20 cm (10½ × 8 in)

This old French farmhouse window was more than just a frame set into a wall. The shutters, window ledge, flowers and cracked plaster were all vital ingredients in the creation of an interesting painting. The glass and curtains were painted with a small brush and a mixture of Payne's Grey with a touch of Ultramarine Violet.

You may occasionally see smaller windows that do not open. These are usually to be found set into interesting walls where additions have been made to an older building, so look for the surrounding fabric and the window ledge in these cases.

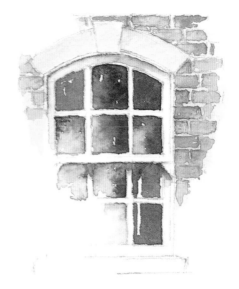

▲ These small town-house windowpanes allowed me to create several broken brushstrokes per pane. White 'flashes' act as reflections. With sash windows, use strong shadow to separate the top frame from the bottom.

▼ A small 'kitchen' window set into a stone wall makes an appealing study. Keep the lintel the lightest tone to help add a sense of 'weight' to the frame. Allow the window ledges to stand out by leaving the top section light and painting heavy shadows directly underneath.

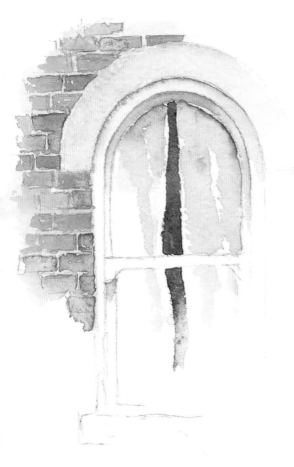

▲ Larger windows allow for a longer sweep of the brush and a more rhythmic style of painting. The folds in the curtains are painted first; this allows you to judge the depth of tone required to paint the gap in between the two curtains. Always try to leave a white edge along the section of the curtain immediately next to the gap – this makes the darks look darker.

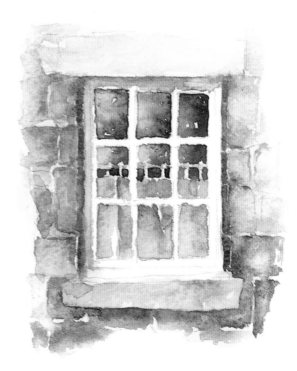

Gates and entrances

Gateways show both the way into and the way out of houses and gardens. They often take on a certain 'protective' quality, marking the boundaries between those areas where the public may stray and those that are deemed to be strictly private.

Most gates, however, are very welcoming visually. Since they are frequently made of wood, often with stone or brick gateposts, the warmth of ageing timber textures,

rusting hinges and soft red brick can create a particularly pleasing first impression.

Sometimes, when painting gates and gateposts, you will need to consider what you can see behind or through the gates. Wooden 'picket' gates, for example, require that you observe what you can see through the individual wooden slats, especially if the gate is whitewashed. You will need to use a small brush to paint the foliage that can be viewed through gaps in order to make the wood stand out. Without the greenery, you would not be able to see white wood at all on white paper.

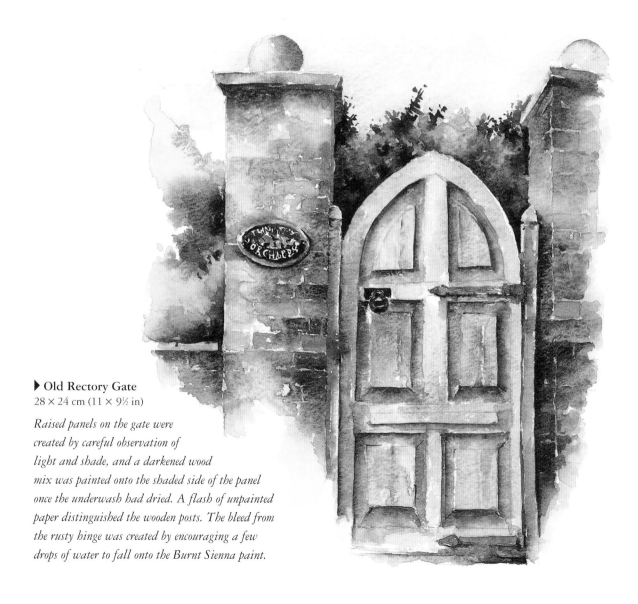

▶ **Old Rectory Gate**
28 × 24 cm (11 × 9½ in)

*Raised panels on the gate were
created by careful observation of
light and shade, and a darkened wood
mix was painted onto the shaded side of the panel
once the underwash had dried. A flash of unpainted
paper distinguished the wooden posts. The bleed from
the rusty hinge was created by encouraging a few
drops of water to fall onto the Burnt Sienna paint.*

▶ *The key to recording this 'colonial' picket gate was close observation of the interplay of the dark background foliage and the light foreground painted wood. The white paper reserved for the gate only appears to glow so brightly because of the strong greens painted behind it. Shadows were painted onto dry paper to secure a clear definition of lines and shapes.*

Painting negative shapes

Wrought-iron gates must be painted in a similar way, only these gates tend to be much more decorative. Start by looking through your subject and establishing exactly what it is that you need to paint that will allow your main subject to be viewed effectively. This is a frequently recurring theme in watercolour painting – sometimes you create a dynamic image by not painting something (in this case a wrought-iron or wooden gate) and leaving it simply as a negative shape.

Finally, look at the textures. Most gates will hold some texture, and this is best created by building up tones through the application of a lot of water and a little paint. This allows watermarks to develop, granulation to occur, and a variety of stain tones to grow on brick, wood or metal.

◀ *This 'thumbnail' sketch of a pair of wrought-iron gates also relied heavily on the colour behind to make the white gates stand out.*

89

DEMONSTRATION *Country Porch*

Occasionally you stumble upon a subject that is
bathed in light, casting shadows across a wall.
The rickety appearance of this old porch with
its wooden struts and loosely secured pantiles
sat easily alongside the weather-stained wall
with its cracked plaster and warm sienna-
coloured bricks. Both together provided an
excellent subject for a study.

Palette

Raw Sienna
Burnt Sienna
Burnt Umber
Raw Umber
Olive Green
Sap Green
Cadmium Yellow
French Ultramarine
Alizarin Crimson
Cadmium Red

An uneven wash of Raw Sienna was applied to
wet paper, using a large brush. Before this had
dried I applied Raw Umber, Burnt Umber and a
little French Ultramarine to create patchy areas
of weathering. As these were applied to damp
paper they dried to a very soft-edged finish.

1

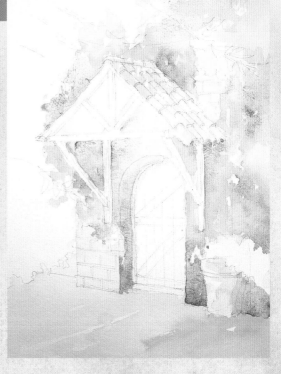

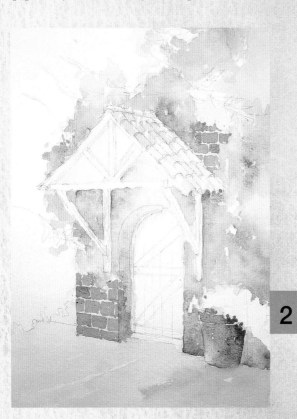

2 When the wall paints had dried I painted the
bricks that could be seen. I did this using a
small brush, painting a mixture of Burnt Sienna
and Burnt Umber onto the brick shapes, leaving
a grid of Raw Sienna showing through to
represent the cement holding them together.

Using the same colours, I painted the pantiles on top of the porch. I took some care to ensure that the areas directly underneath individual tiles were darkened a little, as were the spaces between the rows of tiles.

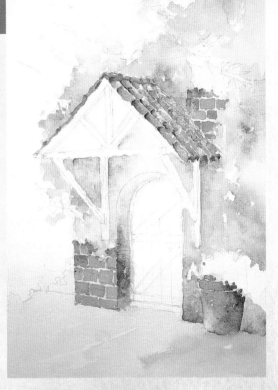

4 The shaded area directly underneath the porch was important as it added visual 'weight'. It was created by mixing Burnt Umber with French Ultramarine and painting 'behind' the woodwork to make it stand out a little more.

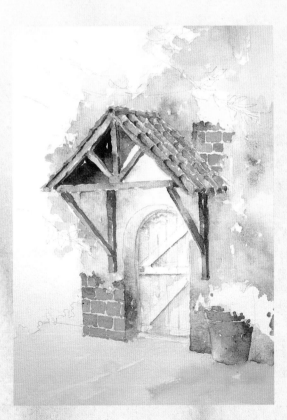

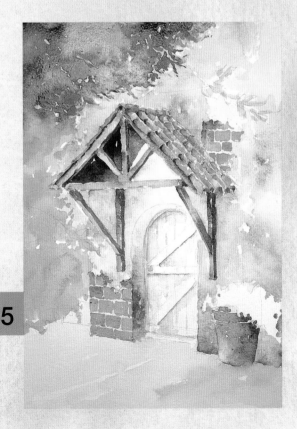

I painted the thick greenery on the left of the building using Olive Green as a base, with a touch of Cadmium Yellow added to create some highlights. As this was drying a little Sap Green and French Ultramarine were mixed and applied to the darker areas.

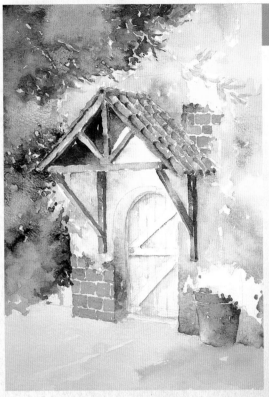

6 Once the foliage paint had dried, a mixture of Sap Green, French Ultramarine and Burnt Umber was used to almost 'draw' the areas of deepest, darkest shadows onto the trees. This, in turn, appeared to push the highlights forward.

7 I made a mixture of Alizarin Crimson and French Ultramarine to create a warm shadow colour. Using a lot of water and a medium-size brush, I washed this across the door and surrounding wall to give the previously painted objects a visual 'lift'.

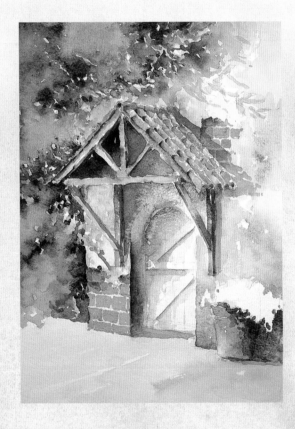

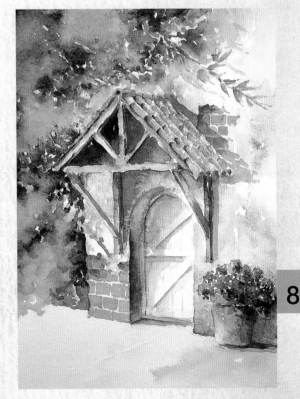

8 The pot of bright red geraniums was next. Cadmium Red with a touch of Alizarin Crimson sat easily against the Sap Green, French Ultramarine and Burnt Umber mix used for the geranium leaves. The pot was painted with Raw Sienna and Burnt Sienna, applied wet-into-wet.

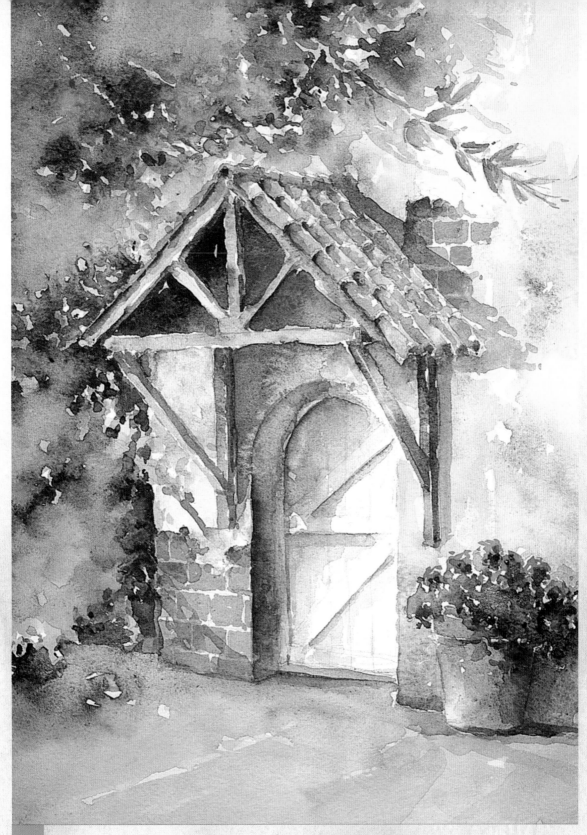

9 **Country Porch**
36 × 24 cm (14 × 9 in)

The watery wash of the soft, warm violet onto the ground helped to cement the composition, and the loose application of paint also complemented the rickety nature of the subject, adding even more to the overall feeling. The warmth of the day was also suggested by the softness of the shadow.

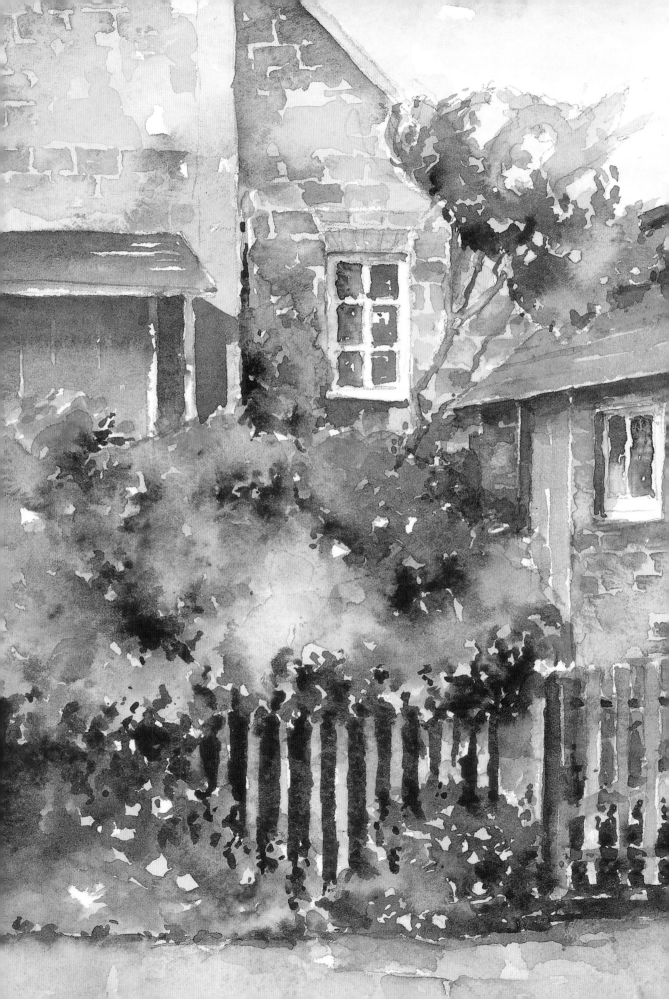

Conservatories & Garden Buildings

As you leave the front of the house and start to move around to the back, a wealth of treasures is likely to unfold – decorative conservatories, rotting potting sheds, summerhouses draped in honeysuckle, and so on.

Always take time to take a look inside these buildings for either the 'accidental' still life, or the ingredients to build your own. A vast range of colours and textures is found on and inside these delightful features and the techniques required to paint them are examined on the following pages.

◀ **Stone and Brick Cottage**
26 × 28 cm (10 × 11 in)

Inside the conservatory

The idea of a conservatory or glass extension to act as a halfway stage between the house and the garden, is particularly appealing from the inside and painting inside a conservatory is understandably popular with artists. You can sit in warmth and comfort and look out across the garden or courtyard (or whatever particular view you happen to have) and paint this at leisure. Sometimes, though, it is a good idea to turn your back on the window and the outside view and paint the actual scene inside the conservatory itself.

One of the key features that you will need to consider when painting inside any structure with a high proportion of glass is the quality of light. Many conservatories are three quarters glass and one quarter house wall. This means that at certain times of the day the light will not be strong (being blocked out by the house), but at other times it will stream through the windows, casting strong angular, hard-edged shadows and illuminating everything it falls upon. This is, I believe, the best time to paint.

Painting the light

To create this type of scene, establish the key colours for the furniture, floor, walls and plants. Paint these features with attention to their shape, but no real concern yet for shadows and shading. When this has dried, consider for a moment the quality of the light.

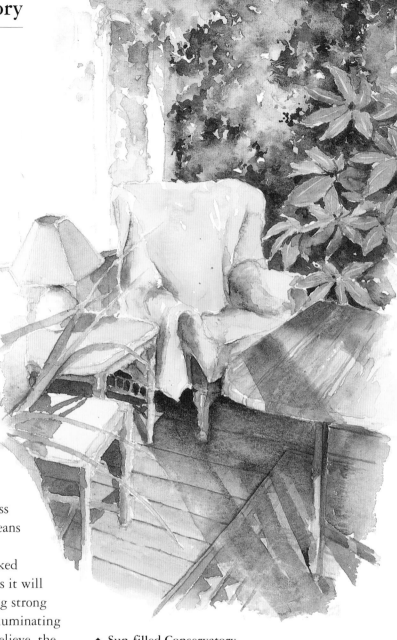

▲ **Sun-filled Conservatory**
32 × 24 cm (12½ × 9½ in)

Harsh lighting throws hard-edged shadows across the floor, table and chairs. The dominant shadows were painted onto a dry underwash, using a 'one stroke' action and resisting the temptation to go back over the applied paint. The deepest shadows in the plants are dark to balance the deep shadows underneath the tables and chairs. Areas outside the conservatory were painted as soft-edged, blurred images.

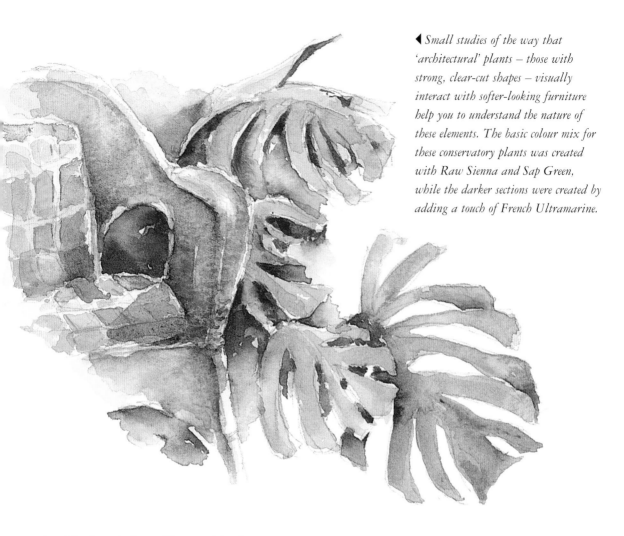

◀ Small studies of the way that 'architectural' plants – those with strong, clear-cut shapes – visually interact with softer-looking furniture help you to understand the nature of these elements. The basic colour mix for these conservatory plants was created with Raw Sienna and Sap Green, while the darker sections were created by adding a touch of French Ultramarine.

A cold winter's day will cast a blue/grey shadow, a fresh spring day will cast a sharp blue/violet shadow, yet a warm summer's day will cast a deep purple/violet shadow. Make your decision and mix your colours.

Painting the shadows requires some bravery. Using a medium-size brush, paint the shadows that you see directly onto your picture with a one-stroke action. Quickly mix up a darker version and, while the paint is still damp, paint this 'underneath' the very darkest areas and allow this to dry to a graduated finish.

▼ Thumbnail sketches of individual plants help you understand the spaces that they require within a composition. Look for the twists and turns in plants – remember that each leaf has an underside. Paint these onto dry paper to allow precision in placing the shading. Use the white paper to act as the central vein that often creates a slight ridge on large leaves.

Outside the conservatory

The symmetrical lines and natural geometry of houses can be broken by the addition of a conservatory to the side or back. For the artist such a building can make a welcome addition to an otherwise flat wall.

There are key factors to consider in looking at the structure of a conservatory with a view to painting it – how many sides are visible, are all the sides at right angles, and what about the angle of the roof? All of these will determine the approach to take in planning a picture or study. The main concern, however, must be how to paint all of the glass, or, more to the point, how to paint all that you can see through the glass. First, you must establish the framework of the conservatory, especially the glazing bars and frames that the glass is set into; this will help to indicate where the sheets of transparent glass are. Then look for any specific light reflections – these often occur when one sheet of glass is set at a slightly different angle to the others – and make a light pencil mark, recording the shape.

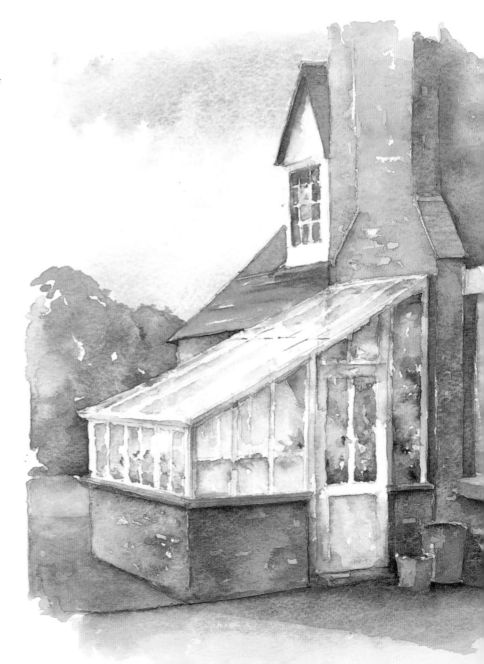

▶ **Brick Conservatory**
28 × 22 cm (11 × 8½ in)

Paint the diffusing effects of glass by using a lot of water and dropping the colours onto wet paper, allowing them to bleed into soft shapes without any clear definition. Foreground shapes need a little more clarity, so allow them to dry with slightly harder edges. Reflections from the sky will appear to be very light, but a little colour will allow the white window frames to be seen still.

▶ *In this study the change of tone from light to dark occurred through three distinct stages. Notice that white blinds do not appear pure white when viewed through glass, so some toning is required to make them appear to 'sit back' from the glass front. Reflections are best painted onto damp paint; just drop on some of the colour of the object being reflected and allow it to bleed, softening the edges.*

Painting diffused colour

To start painting first flood the area inside the conservatory with plain water, working carefully around the white shapes that you have just marked and watch closely as the water sinks into the paper. When the surface water has sunk in, drop in the colours of the objects that you can see through the glass. These colours will dilute considerably as they soak into the damp paper and will also blend a little, creating soft, diffused edges, removing their clarity and suggesting that they are being viewed through slightly dusty glass.

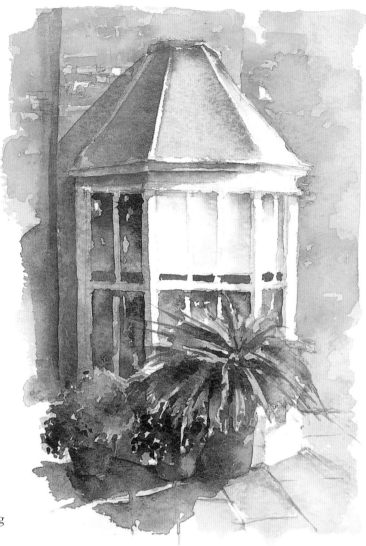

When this process is complete you might wish to take a small brush and, using the tip only, 'dot' in a few darker shapes in flowers, leaves and so on to give a slight 'lift' to the interior without adding any real detail that would contradict the softness of the diffused colours already established.

◀ *'Accidental' still-life groups can be found anywhere. The way in which a pair of muddy Wellington boots sat on the terracotta tiled steps proved irresistible for a thumbnail sketch.*

Sheds and outbuildings

At the bottom of many gardens are to be found wooden sheds or brick outbuildings. They are often passed by for more instantly obvious subjects in a garden such as gnarled trees, flower beds, stone fountains and so on, but these structures can themselves be visually attractive subjects.

While the appearance of an old, weatherbeaten, musty potting shed can be particularly appealing from the outside, you may well find a whole host of treasures inside, ranging from cracked terracotta pots through to rusting garden implements and wheelbarrows. If space is tight and you cannot get inside to paint these wonderfully textured subjects, why not take them outside and arrange them yourself. We have already considered 'accidental' still-life groups (see pages 44–45), but there is no reason at all why you should not establish an intentional still-life group where you take control of the colours, shapes, shadows and textures, and how they all work together in a composition.

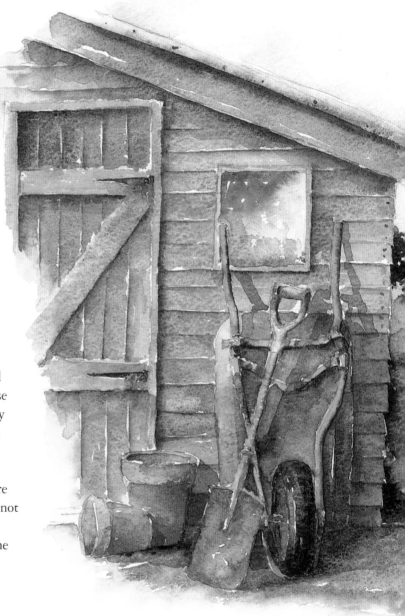

▲ Garden Shed
30 × 23 cm (12 × 9 in)

Shadows cast onto overlapping timbers create a 'jerky' effect. Notice, too, that the interplay of shapes to be found when gardening implements are stacked up can help to make a composition work particularly well. Felt roofs are usually held on with nails, and these can provide an interesting feature to an otherwise dull line of paint.

Visual interaction

Much of the appeal, however, of this type of painting is considering how the fabric of the old garden buildings and gardening implements visually interact. Shadows cast onto overlapping wood, for example, need to be carefully observed for the jagged shapes that are produced.

◀ *The rusting iron texture of this watering can is helped by the granulating effects of Burnt Sienna, Burnt Umber and French Ultramarine, all applied separately to wet paper and allowed to bleed and dry unaided. The deepest tones were created by mixing Burnt Umber and French Ultramarine and applying this to dry paper. Look for the 'underneath' of handles and this will help you to record the way that they appear to twist and turn.*

The way in which many objects share a similar texture, but are separated by strength of colour is also a consideration. For example, terracotta pots and rotting wood share remarkably similar textures, both of which may be created by watermarks and granulation, but they are visually separated by their respective colours – the pots would still retain some of the glow of Burnt Sienna while the wood would likely fade to a dull grey tone.

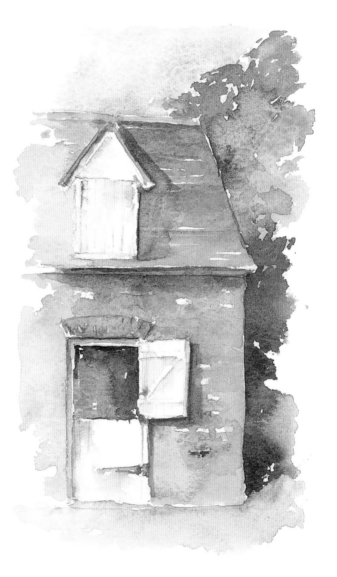

▲ *Lighting is an important consideration when seeking a subject to paint. Strong side lighting, or even lighting from behind, can produce some atmospheric pictures.*

▲ *Old outbuildings with 'stable doors' always provide some interesting features to record. This open door required a little perspective to ensure that it appeared to be sitting at an angle and was not flat against the wall. This was helped even more by the addition of the shadows.*

Summerhouses and gazebos

Summerhouses and gazebos are places where we can sit, rest and relax during the long hot days of summer, often escaping from the intense heat of the day. It is very likely, therefore, that you will feel inclined to paint these garden structures when they are awash with warm shadows cast from the strong sun.

▲ *Sometimes you need to 'look through' your subject to see how to paint it. The white wood here was not painted at all; it is the greenery behind that gives definition. Allowing colours to bleed slightly, especially with outdoor furniture or garden structures such as trelliswork, often results in a more natural appearance.*

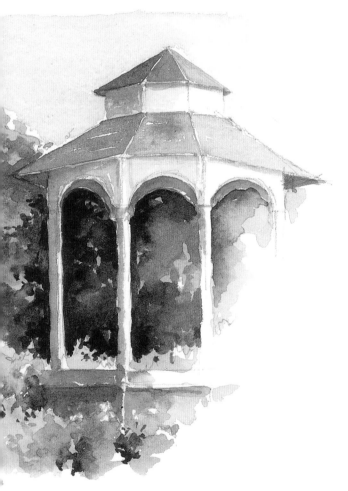

▲ *This simple gazebo was clearly defined by the strength of the greens painted behind it. Look for the changes in tone that multi-sided structures present. Paint the darkest side first, then dilute a little for subsequent sides until you reach the side bathed in full sunlight.*

I personally recommend a three-stage approach to painting these shadows. First, establish the intensity of the shadow colour to be used. French Ultramarine is usually a good base colour. For most rich, redolent summer shadows add a touch of Alizarin Crimson; for slightly stronger, more intense tones substitute Winsor Violet (Dioxazine) for the crimson. Having mixed the colour, apply this using a medium-size brush onto dry paper. Next, look for the darkest area – often inside the summerhouse where little light can penetrate – and, while the paint is still damp, apply a stronger mixture to strengthen the tone. Finally, wash the paint outward at the lighter end of the shadow, creating a dark, middle and light tone, to give the scene more depth.

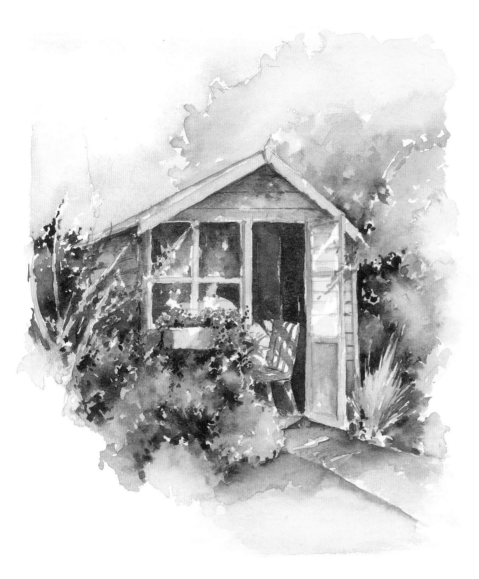

◀ Summerhouse
27 × 23 cm (10½ × 9 in)

Dark interiors are difficult to paint – too dark a shadow will 'flatten' the scene, yet too light a shadow will not create adequate depth. Try to find a corner or edge of wood in dark areas and leave this untouched to prevent the shadow 'swamping' the inside. Angled shadows are particularly important as they, too, prevent interiors from looking 'flat'.

Painting foliage

As gardens are usually full of greenery during the summer months, general foliage will play a role in any composition featuring garden structures. In fact, many gazebos or white painted woodwork are, in reality, visually defined by the greenery of the garden.

To produce the intense bluish greens of the summer garden I recommend that you use an underwash of Olive Green. Once this has dried, add a mixture of Sap Green and as much French Ultramarine as you dare before you think that the mixture could no longer be called green. Then, working onto dry paper,

using a small brush, 'draw' the darkest areas of foliage. This will push the dry Olive Green colour forward, contributing to the three-dimensional effect of your picture. To soften the effect you can 'wash out' the paint towards the bottom of the particular bush or clump of greenery, but leave the paint to dry with a hard line at the top – this will serve to represent the shapes of some of the leaves.

With the darkest tones established, enhance your greens even more. Experiment by adding yellows to create a wealth of new middle tones.

DEMONSTRATION *Waterside Shed*

Although the calm waters of the estuary are not visible in this picture, all the indications of a waterside environment are. The buoys, the lifebelt and the mast are all highly suggestive of the shed's use as a storage area for an abundance of boating bits and pieces. The quantity of blue used in this painting helped to suggest its waterside identity and location.

Palette

Coeruleum
French Ultramarine
Winsor Blue
Olive Green
Sap Green
Burnt Umber
Alizarin Crimson
Raw Sienna
Cadmium Yellow
Cadmium Red

1 For the sky I washed French Ultramarine onto damp paper at the top, and Coeruleum along the furthest visible horizon. When the sky had dried I washed Olive Green onto the background trees and, as it dried, I added Sap Green and French Ultramarine into the shaded areas.

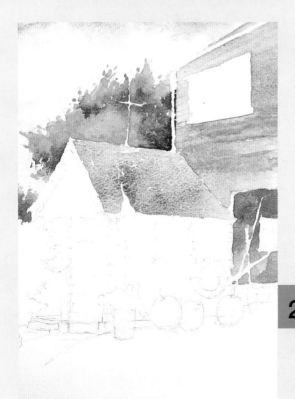

2 The fabric of the buildings needed to be established next. I painted the main, timber-clad building using a mixture of French Ultramarine with a touch of Winsor Blue. The roof of the shed was French Ultramarine with a touch of Burnt Umber. The white wood took care of itself.

The way in which the shadows fell across the buildings was critical to their appearance. Using a watery mixture of French Ultramarine and Alizarin Crimson, with a large brush and a lot of courage, I 'pulled' the shadow colour across the buildings and allowed it to dry with hard lines.

4 When the paint had dried fully, I established the smaller areas of shadows. I added the windows using the blues from the sky and a touch of Burnt Umber. This process can be intimidating, but it is important part of painting.

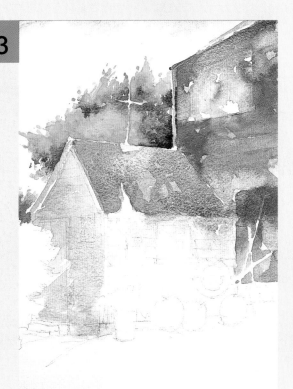

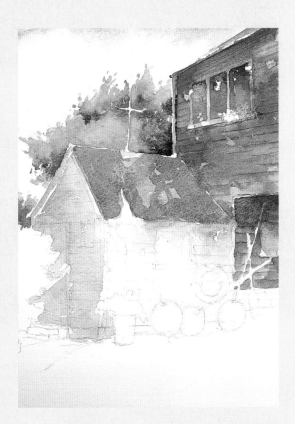

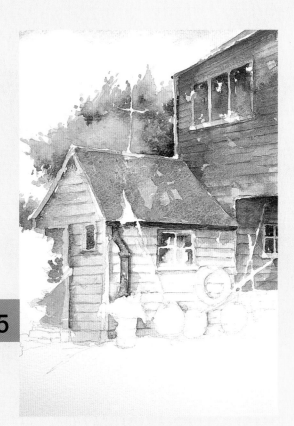

The areas directly underneath the eaves and the window ledges were painted with a small brush and a darker mixture of the basic shadow colour. This was painted onto dry paper with the same small brush, using broken brushstrokes to allow a few white 'flashes' to show through.

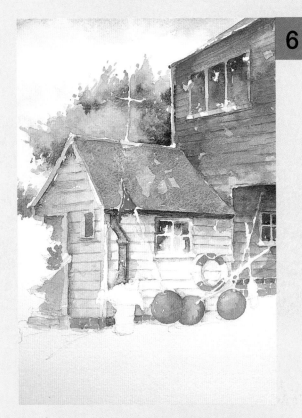

6 The key to the colour balance of this composition lies in the bright orange buoys, and crimson flag, in the foreground. I painted these vibrant areas onto dry paper using a mixture of Cadmium Red and Cadmium Yellow, leaving a few white flashes in the centres of the buoys to suggest reflecting light.

7 The sense of curvature on the buoys was aided by the addition of a little of the shadow colour to their bottoms before the orange had fully dried. The shadows cast behind them onto the shed were painted using the same colour.

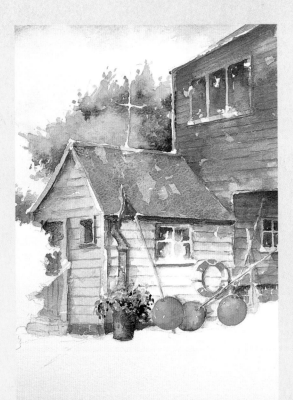

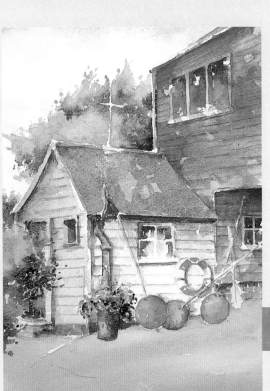

8 I painted the greens in the immediate foreground using a medium-size brush and a mixture of Raw Sienna and Olive Green. This was painted onto dry paper to allow a few highlight flashes of white paper to show through.

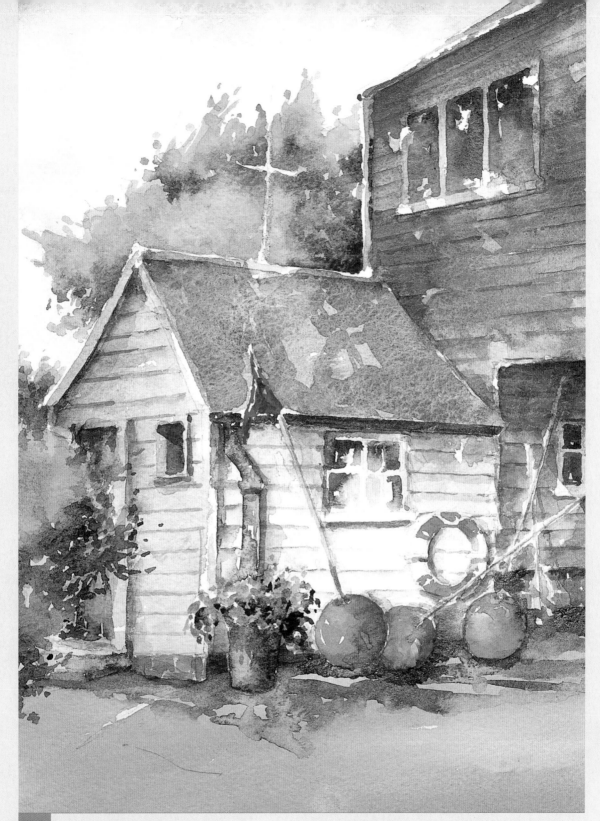

9 **Waterside Shed**
34 × 24 cm (13 × 9 in)

Once the shadows had been painted, anchoring the foreground objects to the grass, the composition was complete. The unifying colour throughout was blue – French Ultramarine and Coeruleum in the sky, French Ultramarine and Winsor Blue in the buildings, and French Ultramarine and Alizarin Crimson in the foreground. All blues have their own qualities, but invariably work well together.

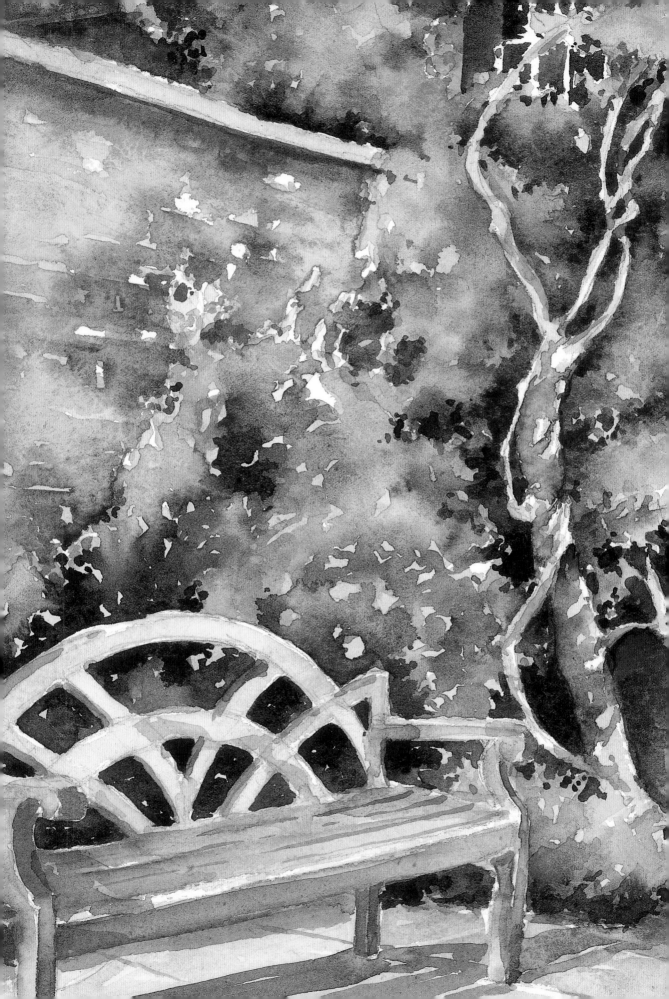

In the Garden

Most houses have some type of
garden attached, even if it is a
small stone courtyard or tiny area
in which flowers, shrubs or even a
few vegetables can be grown. At the
other extreme many homes have
larger and greener gardens where
tall trees cast violet shadows in
summer and orchards shed their
fruits at the turning of the year.

The warmer months encourage
outdoor living and part of this
chapter examines the aspects of
painting garden furniture and
decorative pots and containers.

◀ **Walled Garden**
26 × 28 cm (10 × 11 in)

Flowers in the garden

It is probably true to say that all gardens are flower gardens to some extent as it is extremely unusual to come across a garden without any flowers at all, even if they are only colourful and attractive weeds. This section is not about simply painting flowers; it is about painting flowers as part of a garden, and the critical element of how to balance tone.

Most flowers in a natural setting can be seen clearly as they are viewed against natural parts of their environment such as leaves or stems. It is, therefore, important to ensure neither that the flower heads dominate the composition because they are too bright, nor that the foliage takes over because of its brilliance. Both flowers and foliage need to work in harmony to achieve the critical tonal balance.

Choosing paint colours

Tonal balance is best achieved by careful choice of colours. If you are painting yellow flowers with a Cadmium Yellow base, for instance, it would help the tonal balance of your painting if you used Cadmium Yellow in the leaf mix – for example, Sap Green, French Ultramarine and Cadmium Yellow. If, however, you are painting violet or purple flowers, you will probably have used a blue in the mixture. In that case make sure that you use the same blue when you come to mix the green, maintaining a sense of balance throughout the scene.

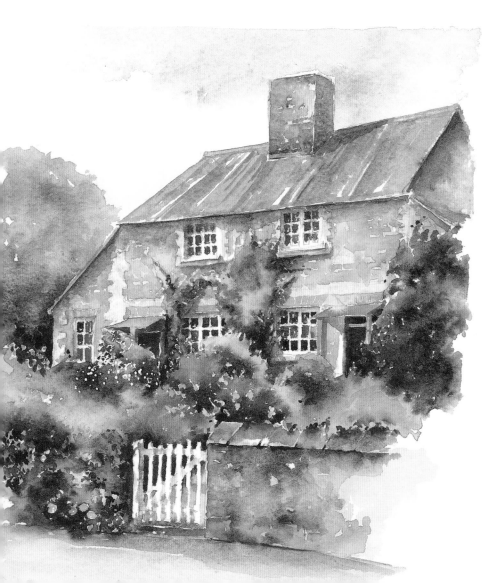

◀ **Cottage Garden**
30 × 27 cm (12 × 10½ in)

Record white flowers amongst a riot of colour by applying tiny dots of masking fluid with a cocktail stick and, when dry, wash dark paint across the masked flower shapes. Once the paint has dried, the masking fluid can be peeled off to reveal a collection of small, white flower heads.

This approach also applies to plants and flowers that are growing in hanging baskets or containers. To maintain the balance ensure that any blues that you use on the flower heads also appear either in the shadows in the case of terracotta or plastic pots, or in the actual colour of the pot itself in the case of metal containers.

▲ *Wild flowers are often found in gardens and it is the randomness of the colours that makes them so appealing to paint. Stems and long leaves can be created by applying a basic underwash and allowing it to dry. A darker mixture can then be used to paint around stem shapes, visually thrusting the lighter-coloured shapes forward.*

▲ *For delicate flower petals use a watery mix of paint; this will dry with a translucent effect, gaining the maximum from the white of the paper. The deepest colours in flower heads are usually seen in the centre. To achieve this apply the colour required onto the centre of the flower while the underwash is still damp, and allow it to bleed gently.*

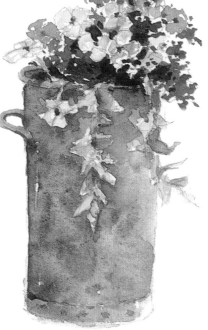

◀ *Many gardens have flowers growing in them, but not always in the ground. Containers can be used to good effect to hold plants. From the artist's point of view, the containers can often be more interesting than the flowers they hold.*

Fruits of the garden

Growing produce, whether fruit or vegetables, in gardens is a universal activity. While their use as food is obvious, they can also provide some wonderfully coloured subjects for the watercolour artist.

Summer and autumn are by far the best seasons to explore gardens for colourful fruit and vegetables. The reds of bush fruits, strawberries and cherries during the summer, and the golden siennas and oranges of apples, squashes and pumpkins during the autumnal months, are a pure delight to collect and arrange. Or you may prefer simply to sketch or paint them in the bush, tree or in the ground as they grow.

Using underwashes

For the summer fruits I usually choose colours from the cadmium range, mainly Cadmium Yellow that I often use as an underwash for particularly bright reds. The reason for this is that Cadmium Red is a rather weak colour on its own and can dry to a disappointing pink if applied directly to white paper. If, however, it is painted on top of a yellow or orange base, it can glow with the radiance of a hot summer's day. For the deeper reds I mix a touch of Alizarin Crimson with Cadmium Red.

▶ Orchard Shadows
30 × 28 cm (12 × 11 in)

The fruit trees in this garden cast a wonderful pattern of shadows in the early summer morning sun. The shadow colours were created by mixing Winsor Violet (Dioxazine) with French Ultramarine and applied rather rapidly, avoiding overworking, with a medium brush onto a dry underwash.

For autumnal fruits and vegetables I use a selection of natural earth colours – chiefly Raw Sienna to act as an underwash, and Burnt Umber in the shadow mixes. The other colours are, again, from the cadmium range. Cadmium Yellow and Cadmium Orange are particularly useful, but do need to be used with some caution as they are both powerful colours and can exert a distracting influence in any composition if the paint is applied too thickly. Finally, when painting apples I tend to use a Sap Green base and soften it with a little Raw Sienna before adding a touch of Burnt Umber and French Ultramarine for the darker areas. These colours are all applied to damp paper to create some graduated shading.

▼ *Marrows, squashes and gourds provided an excellent opportunity to practise mixing yellows and oranges. Cadmium Yellow was used to create the underwash in the vegetables. Once dried, a wash of Cadmium Orange was added, leaving the yellow highlights to show through. Dark shadows were washed onto damp paint, while softer shadows were created by washing onto a dry undercoat.*

▼ *The colours of these apples changed as different shadows fell on them. Small areas of white paper created highlights, but although small, they echoed the shapes of the shed window through which the light fell. Alizarin Crimson and a touch of French Ultramarine were painted onto the dry apples. As the paint dried it granulated, adding to the natural appearance.*

Garden furniture

Few of us choose to sit out in our gardens during the cold, grey winter months, and it is for this reason that most paintings featuring garden furniture are bathed in the dappled shadows cast from the summer sun.

The types of furniture found in gardens vary from ornate cast-iron chairs and tables through to rustic seats hollowed out of fallen tree trunks, but both these extremes cast a variety of interesting shadows and are great fun to paint.

Rather like gates and white fences, you will often have to look through or behind garden seats to be able to paint them successfully. But there is also another element to be considered here. Gardens in the summer are usually awash with long shadows cast by tall, overgrown trees. These shadows fall indiscriminately and follow the shape of any objects that they fall onto. If, for example, a curved garden seat is in the line of a cast shadow, the shadow will follow the curve, helping to define the shape of the seat more clearly, turning the shadow to your advantage.

Painting dappled shadows

Dappled shadows are a frequent feature of summer garden living. These are best painted initially onto dry paper, using a medium size brush to 'draw' the shapes created onto the surface. To create a sense of depth with these shadows, however, use a small brush and wash out the furthest distant shadows a little, softening the edges and leading the viewer's eye out towards the middle ground. The basic colour mix that I use for strong summer shadows is based upon French Ultramarine and Alizarin Crimson, although I occasionally find it useful to add a little Winsor Violet (Dioxazine) to strengthen the mix when required. For slightly softer shadows I use Ultramarine Violet, darkened with French Ultramarine or, again, softened a little with Cobalt Blue.

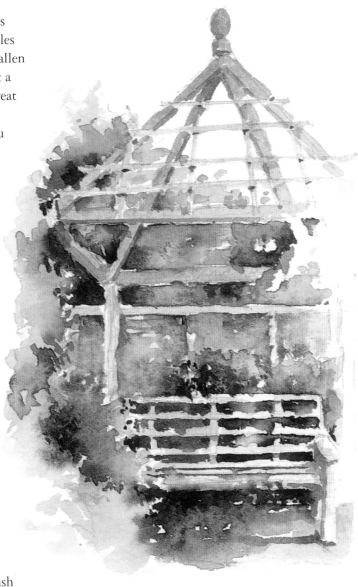

▲ *This small study of a very ordinary-looking garden seat was enhanced by careful choice of tones of green for the surrounding foliage. The darkest greens were mixed with Sap Green, French Ultramarine and a touch of Burnt Umber to make the wooden slats of the seat stand out.*

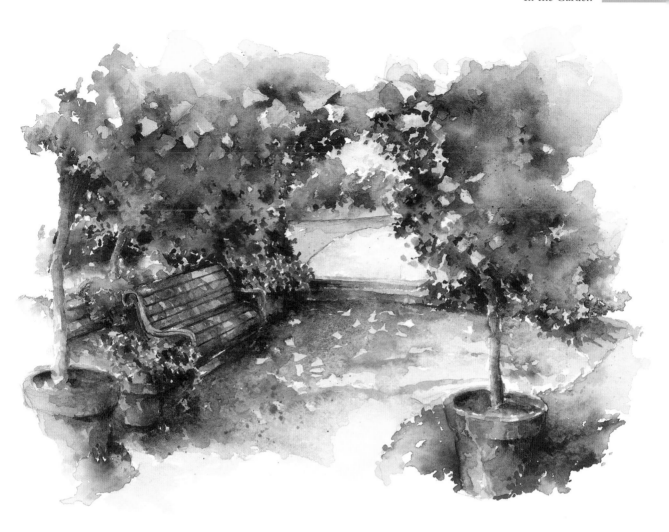

▲ **Dappled Shadows**
23 × 32 cm (9 × 12½ in)

*Dappled shadows, sharp highlights and the redolence of
damp geraniums are all captured in this garden scene,
mainly through pure colour. The curve of the garden seat
is echoed by pulling the shadows around the highlights
using curved brushstrokes. Texture on the ground was
created by spattering Raw Sienna and Burnt Sienna.*

◀ *This unusual seat, built around a tree, offered a
chance to practise perspective drawing as well as
colour mixing. Lemon Yellow and Sap Green
were used in the foliage, while Raw Sienna was
used as the base colour for the wood of the seat.
The soft shadows were mixed with Cobalt Blue and
Alizarin Crimson.*

Courtyards and patios

For many people, a paved courtyard, terrace or patio is an ideal extension of the house, allowing tables and chairs to be set out on a solid surface without fear of muddy shoes or sinking chair legs.

The main themes to consider when painting courtyards are stone and tile textures; initially from the floor, but also from the type of ornamentation often found in these areas. As there is no ground in which to grow flowers or shrubs, pots and containers tend to feature, injecting a sense of colour and natural growth into an otherwise cold stone environment.

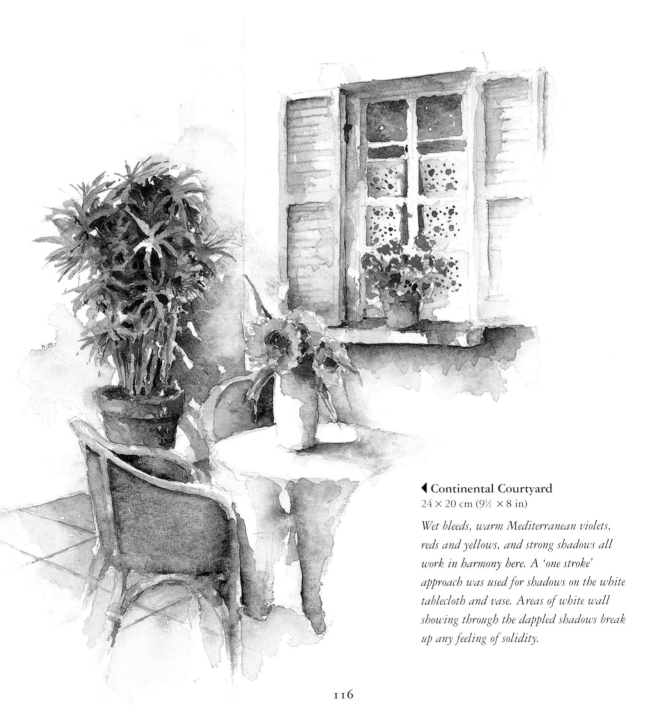

◀ **Continental Courtyard**
24 × 20 cm (9½ × 8 in)

Wet bleeds, warm Mediterranean violets, reds and yellows, and strong shadows all work in harmony here. A 'one stroke' approach was used for shadows on the white tablecloth and vase. Areas of white wall showing through the dappled shadows break up any feeling of solidity.

◀ This old Greek pot, set on a terracotta-tiled floor, was certainly worthy of a study. The rusting metal bar was created by applying pure Burnt Sienna to dry paper, then dropping water on before it dried and allowing this to bleed outwards. The surface of the pot was produced by dropping colours onto damp paper and allowing them to bleed or separate, according to the nature of the pigments.

Painting stone

The key to painting stone is to use vast amounts of water and apply the paint with vigour, flicking the colours on separately. First flick a little Raw Sienna onto wet paint, then quickly flick some Burnt Sienna, followed by Burnt Umber and French Ultramarine. For larger areas of paint try dipping a toothbrush into paint and flicking this, but be careful as the paint will fly in all directions unless you angle it carefully at the section of paper you wish to paint.

Finally, try blotting. A 'scrunched up' piece of kitchen roll can be used to blot some excess water and paint from stone areas. This not only soaks up water, but also forces some paint into the fibres of the paper as they come into contact with it, creating extra texture to add to the previous washing and flicking.

▲ A feeling of 'cold' stone can be achieved by working onto a dry underwash of Raw Umber. A slither of unpainted paper represents the tops of the curves. Running a line of paint onto dry paper underneath a decoration or ridge also helps to reinforce the shape as it dries with a hard edge.

DEMONSTRATION *Early Summer Garden*

The time of the year when the fresh, acidic greens of spring turn into the soft, warm greens of early summer is ideal for painting gardens with many trees growing. The shadows are often a little more gentle and the lighting less harsh than the midsummer days when the sun is at its most intense, and a sense of easy growth sits easily upon mature gardens like the one painted here.

Palette

Raw Sienna
Raw Umber
Burnt Umber
French Ultramarine
Cadmium Yellow
Olive Green
Sap Green
Ultramarine Violet

This scene required a solid pencil drawing, establishing the trees, windows and path within the composition. I painted the building using a wash of Raw Sienna applied to dampened paper. Before this was dry I added a mix of Raw Umber and French Ultramarine to the areas around the doors and windows, where both shading and the effects of the weather and rising damp could be seen.

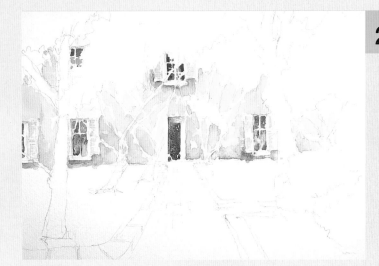

Next, I painted the windows using a small brush and a mixture of Burnt Umber and French Ultramarine. I applied the paint carefully 'around' the glazing bars, leaving these as negative shapes. Reflections were created by using highly diluted paint next to strong paint, with the occasional flash of white paper showing through.

Having completed the building, the foliage of the trees had to be established. Working onto wet paper, I washed Olive Green across the bulk of the foliage. While the underwash was drying Cadmium Yellow was dropped onto the tops and allowed to blend, brightening the tone.

3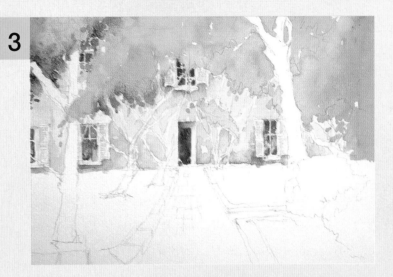

4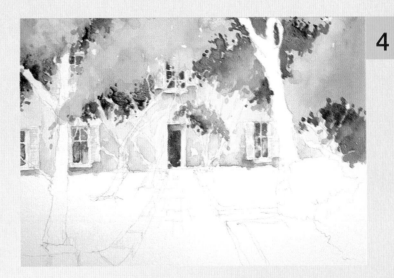

When the underwash had dried I used a dark green, mixed from Sap Green, Burnt Umber and French Ultramarine, to distinguish the different trees. Painting 'behind' one tree tends to push the other tree forward visually in the composition.

Having established the basic undertones, the main colours of the trees could be painted. This involved using a medium brush to wash a light acidic green mixed with Sap Green and a great deal of Cadmium Yellow across the main bulk of the foliage, leaving some of the underwash to still show through and emphasize depth.

5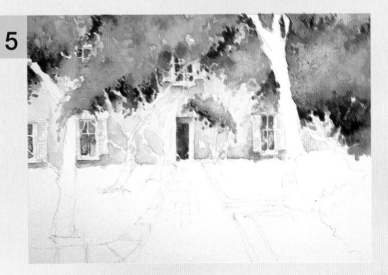

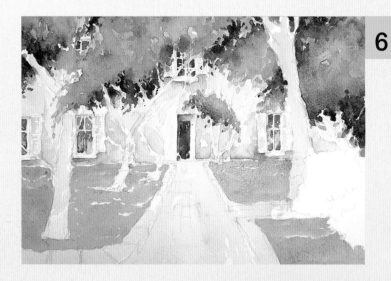

6 The ground needed attention next. This was created by applying a Raw Sienna underwash across the bottom section of the paper. When this had dried I mixed a wash of Olive Green with a touch of the dark tree greens and 'pulled' this across the grass area using the side of the brush.

The tree trunks needed to be completed to make the connection between the upper and lower sections of the composition. Using a lot of very wet paint, I applied Raw Umber, Burnt Umber and French Ultramarine to the tree trunks and allowed the colour to bleed freely.

7

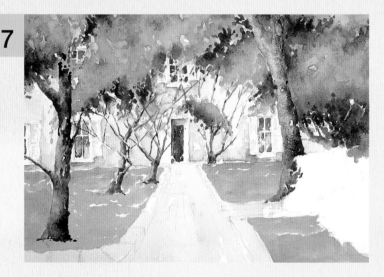

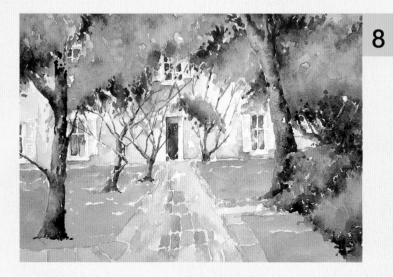

8 The stones in the path were suggested by the use of positive and negative shapes, rather than painting in every one that was visible. These were painted in varying tones of warm grey mixed from Raw Umber, Burnt Umber, Raw Sienna and French Ultramarine.

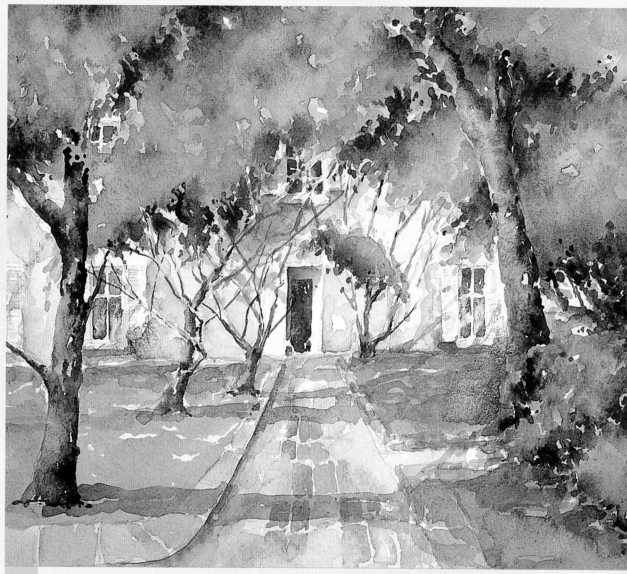

9 **Early Summer Garden**
24 × 34 cm (9 × 13 in)

Once the shadows had been pulled across the ground, dissecting the composition, the interplay of light and shade was complete. The warmth of the day had been established by the use of warm colours – Raw Sienna and Olive Green – and the introduction of a soft violet in the shadows.

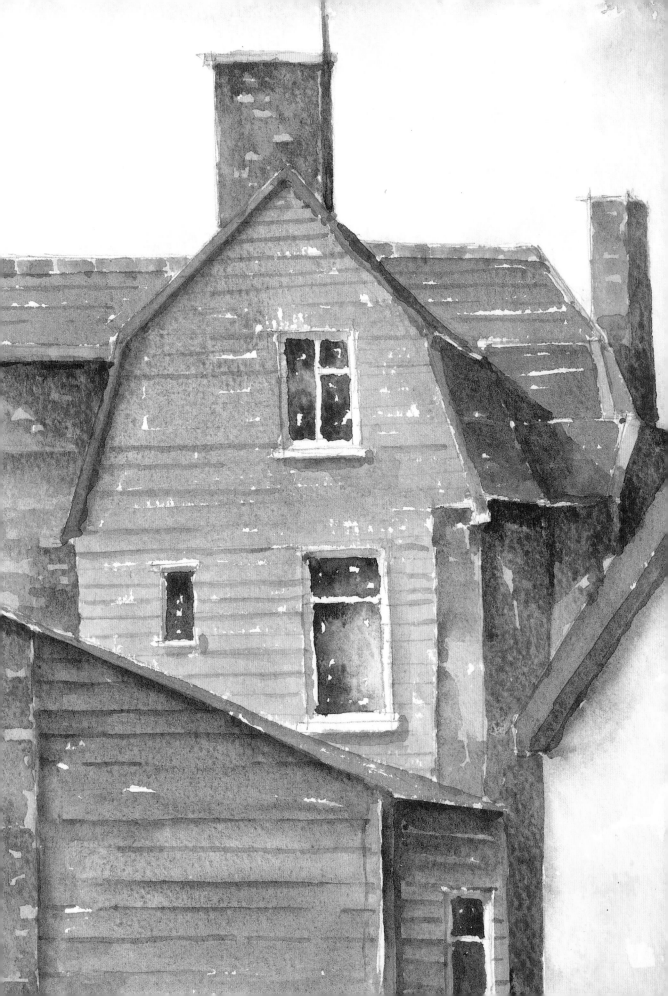

Conclusion

Having completed a 'tour' around assorted houses, and travelled from the front of the building to the outbuildings and garden at the back, it is appropriate to summarize a few important points.

Texture is a particularly noticeable aspect of a house, shed, or even tree, so describing it becomes a priority. Start by learning to use a basic selection of colours well to portray the particular house you are painting. Finally, remember that most houses are special to the people who live in them – after all, they are their homes.

◀ Seaside Rooftops
26 × 28 cm (10 × 11 in)

Experimentation

One of the most important elements any painter can bring to a picture is a highly personal one – the unwillingness to be bound by either pencil lines or self-imposed 'fear' barriers. A blank sheet of paper can be intimidating, but try to overcome this and push these barriers out of your mind. Experimentation is one of the key 'tools' for an artist and, although it might not come naturally at first, it is well worth cultivating.

Experiment with assorted papers until you find the one that suits your needs and style. Then push this to its absolute limits, discovering exactly how far you can go. How much water can you throw at it before the flatness of its surface finally gives way to cockling? How many large brush strokes does

it take to cover a sky? What result do you get when you drag a brush across the 'tooth'? When you have tried all these experiments you will know exactly how much paint to mix with your water, and just how the paper will respond. With this information, and confidence in your materials, you can proceed to create highly textured images.

I limit my palette to a fairly small selection of paints. These are the paints that I have experimented with over a long period and have found suitable to my purpose. I strongly urge you to do the same. Try these paints, and eventually your own preferences will develop. Expand your collection to include the new paints that so frequently appear on the market, but keep your list simple at first.

▼ **White House**
14 × 20 cm (5 × 8½ in)

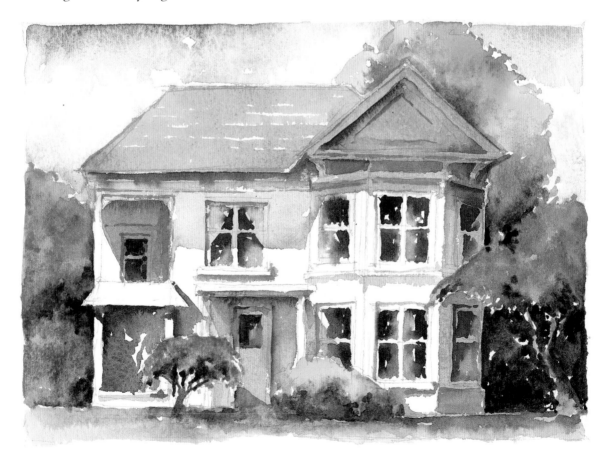

▶ **North African Vista**
22 × 16 cm (9 × 6 in)

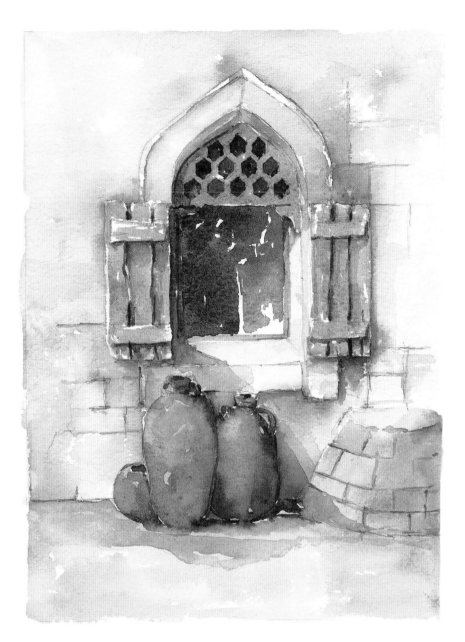

A gentle word of caution

I have undertaken commissions for wealthy rock stars and their mansions, as well as the owners of tiny cottages with barely a penny to their name – but the one thing all these people have had in common is a real pride in their homes. I have yet to meet anyone who has not been flattered to feel that their house is worthy of a painting. The problem of security can,

however, sometimes be of concern to some householders. Your position in front of their house, staring at their front door and making notes on a paper pad may look a little suspicious to some – so be sensitive to this.

Finally, remember that the entire business of sketching and painting is of little value without the pleasure factor – so enjoy your watercolour painting!

Glossary

Background The most distant part at the back of a painting.

Bleeds The running or diffusion of colour that occurs when wet paint is moved across the surface of the paper, usually by another application of paint.

Blending Combining, with an element of control, two or more areas of colour to create a distinctive, clearly defined colour between.

Blotting The removal of any surface water or paint with an absorbent material to create texture or to soften an edge.

Colour temperature The impression of heat or cold that any given colour imparts.

Courtyard An area enclosed by walls or buildings, often opening off a street.

Eaves The underside of a projecting roof.

Flatten To detract from the three-dimensional appearance of any given area.

Foreground The area in the front of your painting.

Gable The triangular upper section of a wall at the end of a pitched roof.

Graduated shading The gradual change that occurs on curved objects as the shading changes from dark to light.

Linear perspective A means of conveying the effects of distance and scale by the use of converging lines.

Middle ground The area between the foreground and the background.

Negative shapes The shapes of the spaces that are around and between the actual shapes that you are painting.

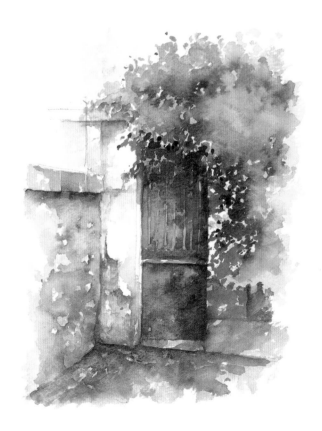

Perspective An optical measuring system developed for translating a three-dimensional scene onto a flat sheet of paper.

Porch The covered entrance to a building.

Positive shapes The actual shapes of the object you are painting.

Pulling paint A particularly positive brushstroke in which water or paint is brushed away from a specific point.

Runs These occur when wet paint is moved across the surface of the paper, usually when some additional paint is applied.

Stucco Cement or plaster coating for exterior walls, also used for decorative mouldings.

Terrace A row of attached houses built as one unit.

Thatch A roof covering made of straw and reeds.

Tonal perspective The use of tones to convey a sense of distance and scale by using lighter tones in the background and stronger tones in the foreground.

Translucency The main quality of watercolour paints – clear, but only partially transparent.

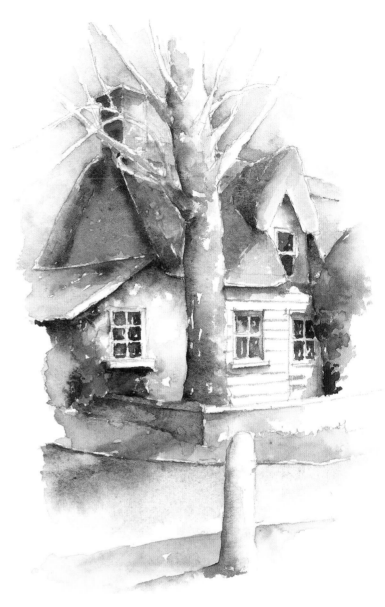

Wash The application of either paint or water in fluent strokes.

Weatherboarding Overlapping horizontal planks or boards of wood covering timber-framed walls.

Wet-into-wet A technique that involves applying wet paint to a wet or damp sheet of paper, causing the paint to bleed outwards.

Index